W9-AVW-004

Planning, Designing, and Decorating a Room Step by Step:

A How-to Manual for Anyone

Charlotte Finn

Drafting Illustrations by Steve Roberts

PEARSON

Prentice Hall

Upper Saddle River, New Jersey 07458

Library of Congress Cataloging-in-Publication Data
Finn, Charlotte.
 Planning, designing, decorating a room step by step : a how-to manual for anyone / by
Charlotte Finn.— 1st ed.
 p. cm.
 Includes bibliographical references.
 ISBN 0–13–111614–2
 1. Dwellings—Remodeling. I. Title.

 TH4816.F574 2006
 747—dc22

 2004016715

Executive Editor: Vernon R. Anthony
Editorial Assistant: Beth Dyke
Director of Production and Manufacturing: Bruce Johnson
Managing Editor: Mary Carnis
Manufacturing Manager: Ilene Sanford
Manufacturing Buyer: Cathleen Petersen
Production Editor: Melissa Scott, Carlisle Publishers Services
Production Liaison: Janice Stangel
Creative Director: Cheryl Asherman
Senior Design Coordinator: Miguel Ortiz
Cover Design: Jill Little, iDesign
Cover Art: Cover photo courtesy of Charlotte Finn
Senior Marketing Manager: Ryan DeGrote
Senior Marketing Coordinator: Elizabeth Farrell
Marketing Assistant: Les Roberts
Composition: Carlisle Publishers Services
Printer/Binder: Banta Harrisonburg

All photos courtesy of Charlotte Finn.

Author photo on back cover courtesy of Dyana Van Campen.

Copyright © 2006, by Pearson Education Inc., Upper Saddle River, New Jersey 07458. All rights
reserved. Printed in the United States of America. This publication is protected by Copyright and permission
should be obtained from the publisher prior to any prohibited reproduction, storage in a retrieval system, or
transmission in any form or by any means, electronic, mechanical, photocopying, recording, or likewise. For
information regarding permission(s), write to: Rights and Permissions Department.

Pearson Prentice Hall™ is a trademark of Pearson Education, Inc.
Pearson® is a registered trademark of Pearson plc
Prentice Hall® is a registered trademark of Pearson Education, Inc.

Pearson Education LTD.
Pearson Education Singapore, Pte. Ltd.
Pearson Education Canada, Ltd.
Pearson Education—Japan

Pearson Education Australia PTY, Limited
Pearson Education North Asia Ltd.
Pearson Educación de Mexico, S.A. de C.V.
Pearson Education Malaysia, Pte.Ltd.

10 9 8 7 6 5 4 3 2 1
ISBN 0-13-111614-2

CONTENTS

LOG FOR ILLUSTRATIONS

Lighting

Architectural Elements

Accessories

Worksheets

Solutions 1–C to 7–C

DESIGNING YOUR ROOM

INTRODUCTION

Welcome to the real world of interior design! As the title suggests, this book will present a logical, step-by-step approach to the project of designing and decorating any and all rooms. The book is divided into two sections: Designing Your Room and Decorating Your Room. The technical section, Designing Your Room, outlines the systematic steps to be taken for any and all good design work with the ultimate goal of creating an attractive, functional floor plan and room arrangement.

Whether you would like to work in a design studio or be employed by a store as a salesperson/interior designer, or most likely to design and decorate your own home, the basis of all good design work is the floor plan. Acquiring the knowledge, techniques, and specific information about your lifestyle is an art in itself. Being successful here will allow you to make the proper decisions to design workable, successful, creative floor plans and room arrangements.

In order for you to have a clear understanding of this technical procedure, we have explained and illustrated in the following pages the process of measuring a room properly, making a proper drawing of the room with details, and then conversion to scale for the drawing of the measurements of the room. In addition, we have broken your home into its various rooms, i.e., living room, dining room, master bedroom, etc., and have included a pertinent questionnaire for each room which, when answered, will guide you in the drawing of that particular floor plan, which is the most important and first step in any and all good design work. *And then* we have drawn for your study, *floor plans of these specific rooms* as a result of the direct answers to the questionnaire which we have presented and answered for your study.

With all this very basic information and important illustrations that we have provided the step-by-step procedure outlined in the following pages can be applied to all projects, whether the rooms are small or large in size, for very wealthy homes with large budgets, or for very modest homes with small budgets.

FLOOR PLANS AND ROOM ARRANGEMENTS

Floor plans and room arrangements are the cornerstones of your entire interior design process. The floor plan is a **map** of the room. Room arrangement, room size, and the position of furnishings are established at this important stage. The arrangement of furniture in the floor plan affects seating groups for conversation and traffic patterns, and it creates a focal point, such as a fireplace (Illustration A–1), a home entertainment unit (Illustration A–2), or a particularly lovely view (Illustration A–3).

The following text will outline the steps you should follow to create a pleasing and functional floor plan. Eventually you may learn AutoCAD, a computer program, that will do what you will be doing by hand now. However, it is essential for you to have a thorough knowledge and command of the rudiments of the process—in a manner similar to that of a pianist learning scales—before you start using more advanced methods and tools. To emphasize our belief in the importance of the manual learning process outlined in this book, all the technical drawings in this book have been created by hand. When these steps are understood and mastered, using the computer to accomplish this work will make your execution of the plans thoroughly professional.

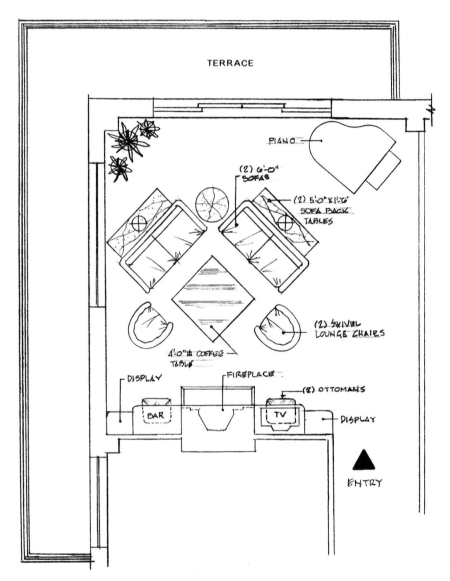

FOCAL POINT FACING FIREPLACE

Illustration A–1

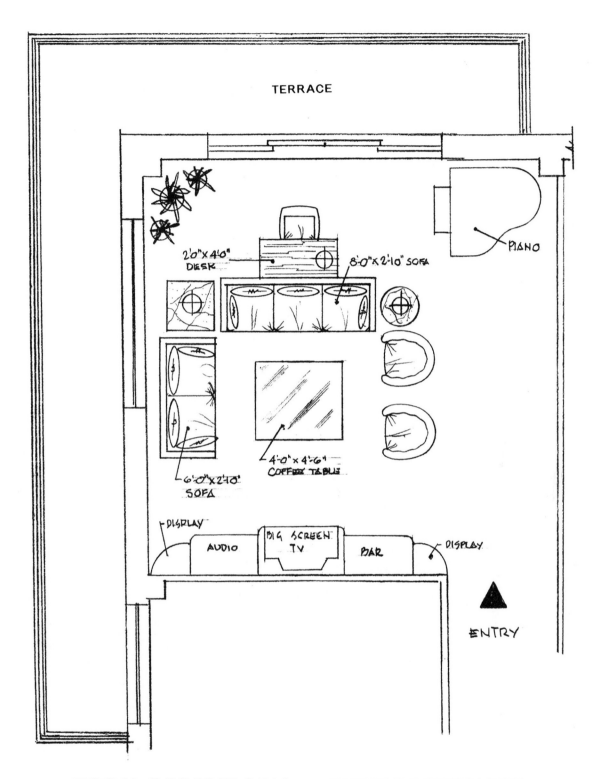

FOCAL POINT FACING ENTERTAINMENT UNIT

Illustration A-2

TERRACE

WALL HUNG
LARGE SCREEN
TV

DISPLAY
4'-0" X 1'-3"

4'-6" SQUARE
COFFEE TABLE

2'-10" X 7'-0" SECTIONAL
SOFA

2'-0" X 4'-0" DESK

2'-10" X 2'-10"
SOFA CORNER

7'-0" X 15" DISPLAY UNIT

ENTRY

FOCAL POINT FACING VIEW

Illustration A-3

HOW TO DRAW AN OUTLINE OF YOUR ROOM

Before doing anything else, you will need to take accurate measurements of the room. **Do not** take any **physical measurements** at this beginning step. Instead, make a rough drawing of the shape of the room you are to design. You will find that most rooms fall into one of three basic shapes: a rectangle, a square, or an L-shape (Illustration B–1).

 After drawing a plain outline (Illustration C–1) using the proper symbols (Illustration C–2), add the approximate position of doors and their swings (left or right), entrances, windows, sliding doors, fireplaces, and any other identifiable architectural elements. We will label this line drawing "Your Room Diagram" (Illustration C–3). You are now ready to take actual physical measurements of the room and to put these measurements in the proper places on "Your Room Diagram." **Do not be concerned with scale at this point.**

THREE ROOM SHAPES

RECTANGULAR-SHAPED ROOM

L-SHAPED ROOM

SQUARE-SHAPED ROOM

Illustration B–1

OUTLINE OF FAMILY ROOM

FAMILY ROOM

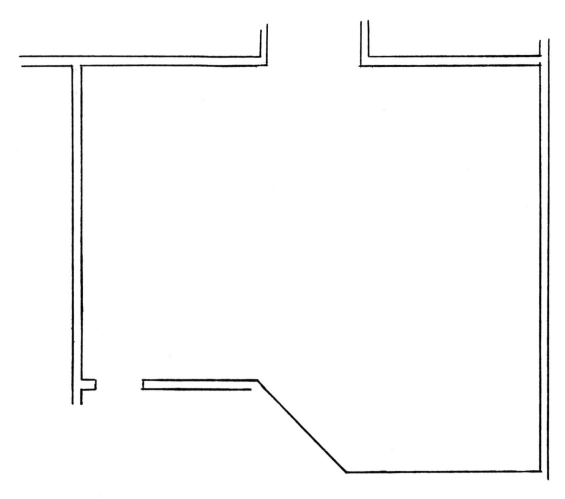

REPRESENTS EXISTING WALL THICKNESS

Illustration C-1

DOOR, WINDOW, STAIR & FIREPLACE LEGENDS

DOORS

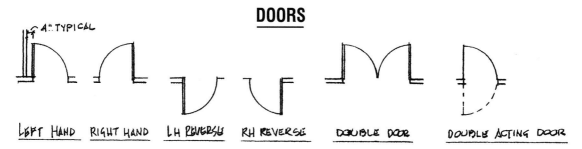

LEFT HAND RIGHT HAND LH REVERSE RH REVERSE DOUBLE DOOR DOUBLE ACTING DOOR

THE 4" TYPICAL DIMENSION FROM THE DOOR TO THE WALL IS TO TAKE INTO CONSIDERATION THE DEPTH OF THE KNOB SO THE DOOR CAN OPEN 90° AND NOT HIT THE WALL - A FLOOR OR WALL STOP IS STILL NEEDED

BI-FOLD DOOR DOUBLE BI-FOLD POCKET DOOR PAIR OF SLIDING DOORS FOLDING DOOR

WINDOWS

DOUBLE HUNG WINDOW CASEMENT WINDOW FIXED WINDOW BAY WINDOW

FIREPLACES STAIRS

HEARTH
RECESSED FIREPLACE

HEARTH
WALL FRAMED FIREPLACE

HEARTH
CORNER FIREPLACE

CONTEMPORY TRADITIONAL

Illustration C-2

7

YOUR ROOM DIAGRAM

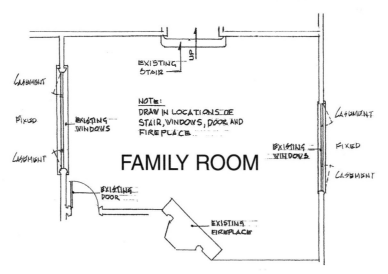

Illustration C–3

TAKING DIMENSIONS OF A ROOM

Stand in the middle of your room, as shown in Illustration D–1. We have marked the wall you are facing as "A." Always start in the left-facing corner and measure from left to right (clockwise). Record the measurements between architectural elements as well as the measurements of the elements themselves and label these on your diagram (Illustration D–2). When this is completed, measure and record the width and length of the room. This will serve to double check that your measurements going around the room are correct. The architectural element-to-element measurements should equal the actual length and width of the room (Illustrations D–2 and D–3).

Now that you have the actual physical measurements and an accurate outline and drawing of your room diagram, you are ready for the next step: **converting** the measurements to scale. Making a scaled drawing permits you to read your outline and subsequent measurements of furnishings, traffic patterns, architectural elements, and entire rooms in simple, accurate, and easily identifiable numbers (Illustration E–1).

To make this conversion, you will first need to decide what scale you wish to use. The scale that is easiest to read and the most commonly used is 1/4″ = 1′.

Once you have determined your scale, you can re-draw your room diagram to scale (Illustration E–2).

Now that you have mastered the skill of accurately measuring your project and converting these measurements to scale (Illustration E–2), it is also important for you to note the existing locations of the following elements before proceeding:

1. Door and window frame detail
2. Height of the room
3. Heat and ventilation locations
4. Existing electrical outlets
5. Existing lights
6. Existing telephone plugs
7. Existing cable and TV outlets
8. Existing closets
9. Existing built-ins

After you have completed the technical tasks of defining the shape of your room, taking measurements, and converting the diagram to a scaled drawing, you are ready to learn how to acquire the information pertaining to the room or rooms that will be necessary in creating a functional, interesting floor plan.

ROOM DIAGRAM

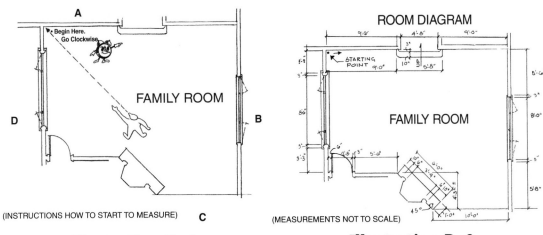

A

FAMILY ROOM

D

B

(INSTRUCTIONS HOW TO START TO MEASURE) C

Illustration D–1

ROOM DIAGRAM

FAMILY ROOM

(MEASUREMENTS NOT TO SCALE)

Illustration D–2

ROOM DIAGRAM

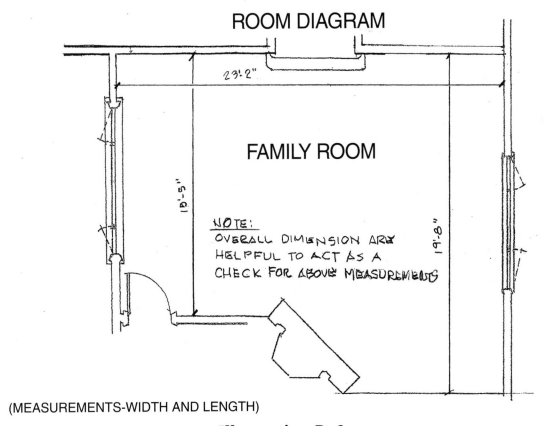

23'-2"

FAMILY ROOM

15'-5"

19'-8"

NOTE:
OVERALL DIMENSION ARE
HELPFUL TO ACT AS A
CHECK FOR ABOVE MEASUREMENTS

(MEASUREMENTS-WIDTH AND LENGTH)

Illustration D–3

SCALE RULE & ITS USES

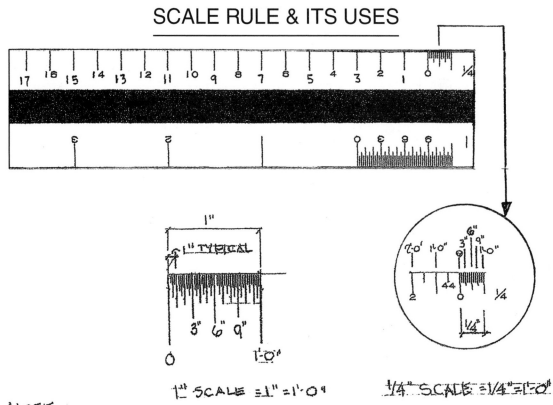

1" SCALE = 1" = 1'-0"

1/4" SCALE = 1/4" = 1'-0"

NOTE
ON THE 1/4" = 1'-0" THE LINE
SEGMENTS ARE DIVIDED SO
EACH LINE REPRESENTS 1 INCH
IN LARGER SCALES SUCH AS
1" = 1'-0" EACH LINE REPRESENTS
1/4"

A SCALE RULE IS IMPORTANT TO BE ABLE TO REDUCE FULL SIZE DIMENSIONS
INTO A SMALLER SCALE SO THAT YOUR DRAWING CAN FIT ONTO SMALL SIZE PAPER
ON WHICH YOU CAN DRAW PLANS WHICH CAN LATER BE USED AS AN ACCURATE
GUIDE FOR PLACING FURNITURE BUILT-IN UNITS, LIGHTING, TELEPHONE &
ELECTRICAL OUTLETS IN THE ACTUAL FULL SIZE ROOM, WHICH YOU HAVE DRAWN
TO SCALE. PLASTIC FURNITURE, CIRCLE TEMPLATES & TRIANGLES ARE ALSO
HELPFUL (SEE ILLUSTRATIONS H-2)

Illustration E-1

ROOM DIAGRAM DRAWN TO SCALE

FAMILY ROOM

ROOM DRAWN AT $\frac{1}{4}$" = 1'-0" SCALE

Illustration E-2

HOW TO ACQUIRE NECESSARY INFORMATION

At this stage you should ask yourself certain questions; their answers will guide and influence the direction you take in the creation of the room arrangement.

These questions, which will be identified as the first section, or **General Information,** of your "Designer Notes," should be presented as multiple choice. Using this format will narrow the answers to the information you need, making those answers more precise and more specific. (This technique and approach to taking good notes should guide you throughout the entire interior design process.)

Without this guidance and structure, the answers can be too vague. It is very important that the answers mean the **same thing** to you as what you, or in the case of clients, what they have in mind. The narrower and more precise the answers, the more helpful they will be.

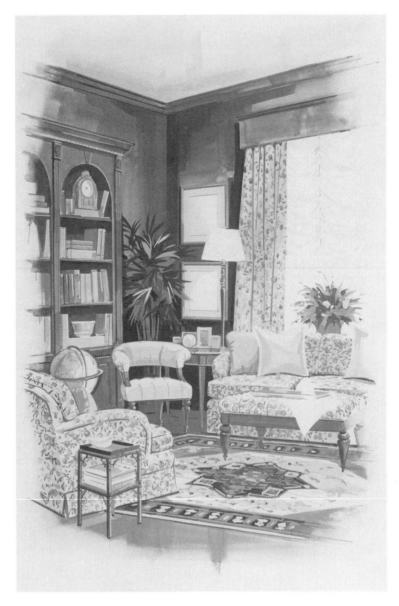

Illustration F–1 English

With experience, asking these questions will become almost automatic. Remember, the entire project will start off on the wrong foot without the proper phrasing, order, and directness of these questions, which are of paramount importance in affording you the insight necessary to create the plan.

DESIGNER NOTES

Regardless of the type of room or rooms you are designing, you should first ask yourself General Information Questions at the outset of any project. We will call them the "General Information" of your Designer Notes. The answers to these questions will set the stage for the development of the entire project.

These questions will provide insight regarding the overall lifestyle, informing you of the type of home (number and approximate ages of children versus empty-nesters) as well as style preferences (English, Country French, Contemporary, Art Deco, etc.; Illustrations F–1, F–2, F–3, and F–4). This overview will apply to any and all specific rooms in the home you might be asked to design.

With experience you will undoubtedly build, revise, and add to these questions, depending on your socioeconomic background, but if you adhere to these basic ones in the beginning and the formation and wording is based on a multiple-choice format, your success rate will be very high. The following is a list of suggested questions.

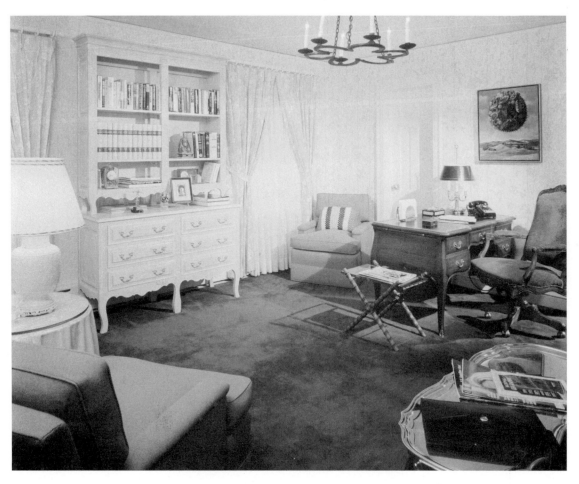

Illustration F–2 Country French

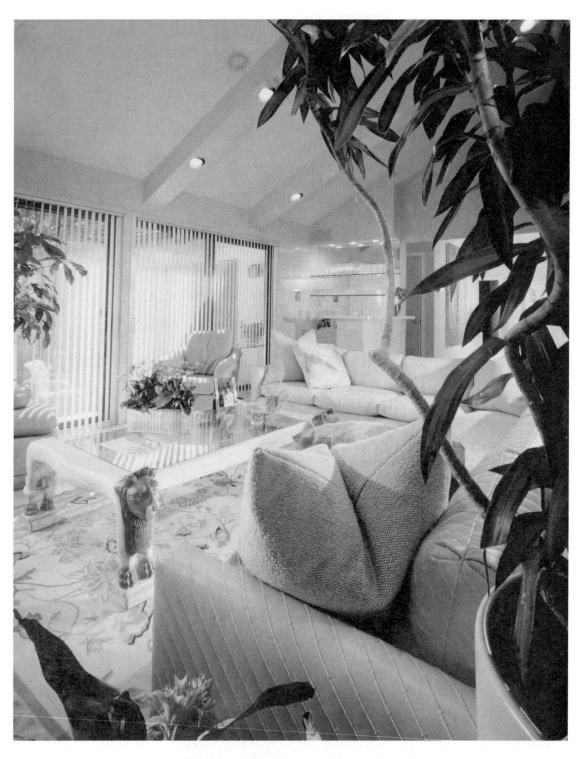

Illustration F–3 Contemporary

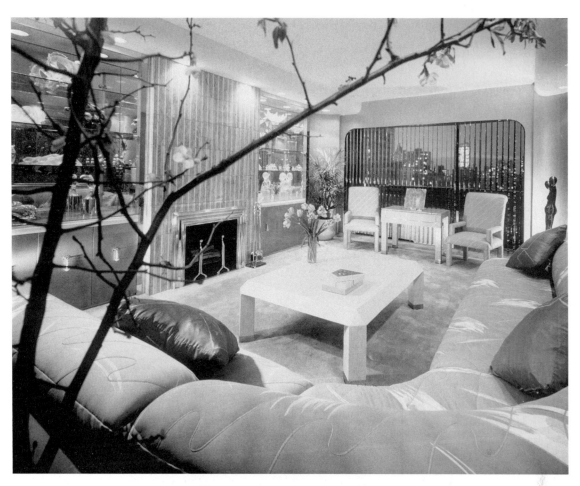

Illustration F–4 Art Deco

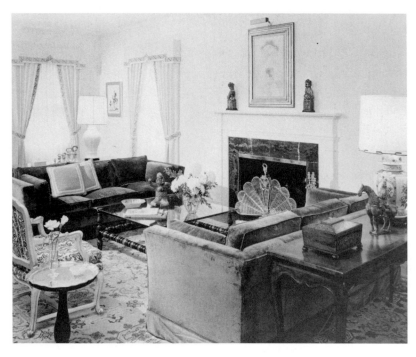

Illustration G–1 Formal

General Information Questions

(We have answered these general questions for one hypothetical customer and that person's home. The answers are reflected in Illustrations H–1, I–1, J–1, K–1, and L–1; these drawings will be used as floor plan illustrations for the rooms in the following sections.)

1. Is your home a

country home	____ Yes	____ No
city apartment	____ Yes	____ No
vacation home	____ Yes	____ No
primary residence	✔ Yes	____ No

2. If your home is a vacation home, is it a

ski home	____ Yes	____ No
beach home	____ Yes	____ No
golf-tennis home	____ Yes	____ No
other—primary	✔ Yes	____ No

3. Do you have children at home? If so, what age group?

children	____ Yes	____ No
infants to 12 years	____ Yes	____ No
teenagers	____ Yes	____ No
college age	✔ Yes	____ No

4. Is your home for

a single woman	____ Yes	✔ No
a single man	____ Yes	✔ No

5. Do you have any pets? ____ Yes ✔ No

6. Would you like your rooms to be

formal (Illustration G–1)	____ Yes	____ No
casual (Illustration G–2)	✔ Yes	____ No

7. What period or style do you prefer your rooms to be?

Western American (Illustration G–3)	____ Yes	____ No
Early American	____ Yes	____ No
Traditional English	____ Yes	____ No
Formal English	____ Yes	____ No
Country French	____ Yes	____ No
Formal French	____ Yes	____ No
Contemporary (Illustration G–4)	✔ Yes	____ No
Country Casual (Illustration G–5)	____ Yes	____ No
Eclectic (Illustration G–6)	____ Yes	____ No
Art Deco	____ Yes	____ No
Oriental (Illustration G–7)	____ Yes	____ No

8. Do you want to use this room primarily for

entertaining	✔ Yes	____ No
entire family	✔ Yes	____ No

With this basic information about your lifestyle, you are prepared to ask more specific questions identifying the type of room to be designed and the elements you would like the room to include.

Illustration G–2 Casual

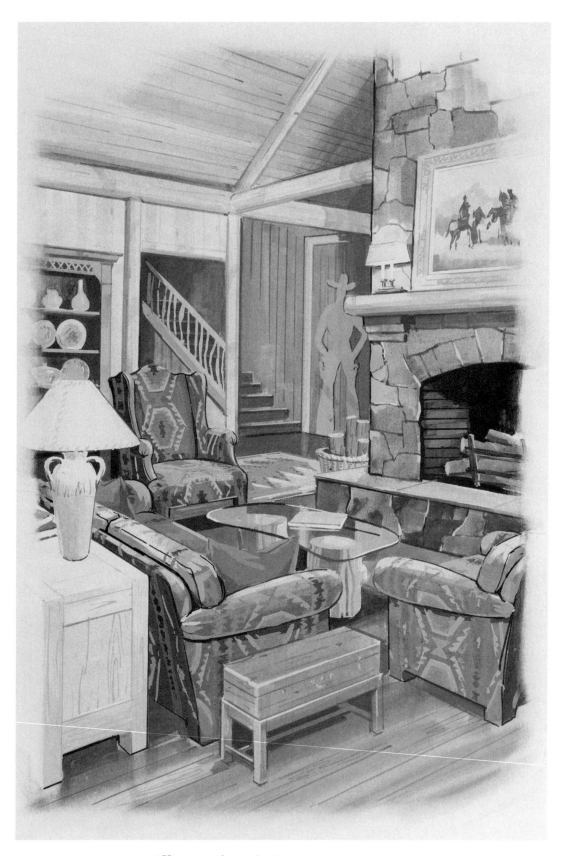

Illustration G–3 Western American

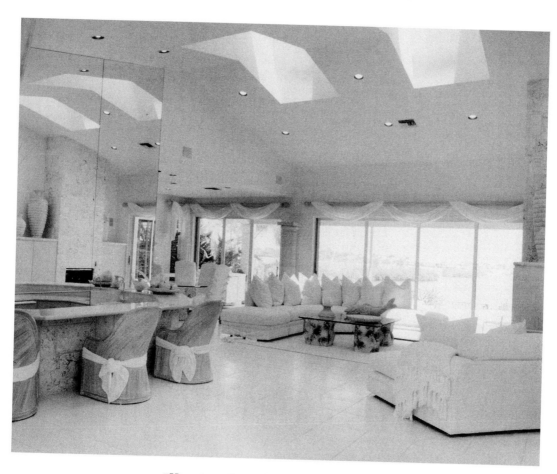

Illustration G–4 Contemporary

Illustration G–5 Country Casual

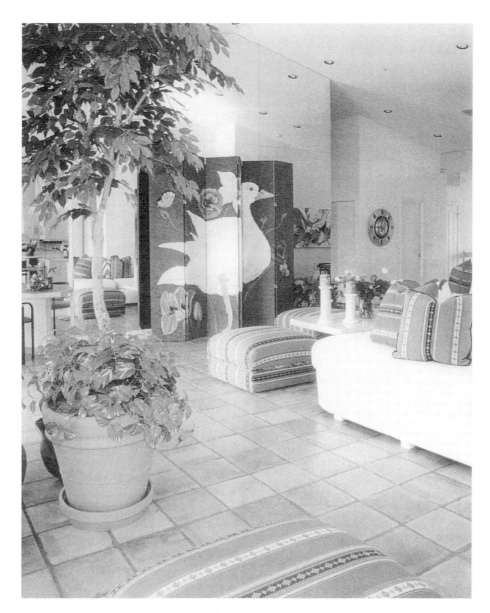

Illustration G–6 Eclectic

Specific Questions for Specific Rooms

After asking the General Information Questions, you will need to follow-up with specific questions about specific rooms. Questions for each room should be asked **separately** to eliminate confusion. It is not necessary to ask what size bed is desired for a living room, for instance; this question should only be asked if a bedroom is being designed.

The following pages contain questions for specific rooms. These are designed to give you the information needed for various rooms (i.e., a living room, a family room, a master bedroom, a dining room, a home office, etc.) in the execution of their floor plans. Remember, when working with any room, you must always refer back to the answers to the General Information Questions as well.

Illustration G–7 Oriental

As you can see, we have answered the questions for each specific room in a hypothetical manner and have **used those answers** to illustrate their relationship to a floor plan by drawing floor plans of those rooms as **examples for you to study**. These examples will show you how to get to the ultimate goal of a finished floor plan step by step.

At the very end of the book, we have also provided activity worksheets for you to practice all that you have learned on seven additional hypothetical rooms. In these exercises **you are to execute the floor plans yourself** using the answers provided in the corresponding questionnaires.

Living Room/Family Room/Great Room/Den/Study/Library Questionnaire (Illustration H–1)

Items

1. Which room are we working on?

A	____	Living room
B	✔	Family room
C	____	Great room
D	____	Den
E	____	Study
F	____	Library

2. Do you want to use this room for TV-HiFi-VCR? ✔ Yes ____ No

 Home entertainment? ✔ Yes ____ No

 If so, do you want an entertainment center? ✔ Yes ____ No

3. Do you want to provide for a bar in this room? ✔ Yes ____ No

4. Do you want the bar to be ____ Wet ✔ Standing ____ Sitdown

5. Do you want to provide an area for books? ✔ Yes ____ No

6. Do you need a sleeper sofa in this room? ____ Yes ✔ No

7. Is a recliner important in your room? ____ Yes ✔ No

8. Do you play cards or games? If so, do you want a card table in this room? ✔ Yes ____ No

9. Do you need a desk? ✔ Yes ____ No

10. Should seating accommodate

6–8 people?	____ Yes	____ No	
8–10 people?	____ Yes	____ No	
10–12 people?	✔ Yes	____ No	

11. Do you have any built-ins existing in your room? ____ Yes ✔ No

12. Do you want to provide for display? ✔ Yes ____ No

13. Do you want a fireplace?

new	____ Yes	____ No
existing	✔ Yes	____ No
existing modified	____ Yes	____ No

In addition to the floor plan (Illustration H–1) for the family room, we also have included Illustration H–2, which shows you a number of drafting tools you can use in the execution of floor plans.

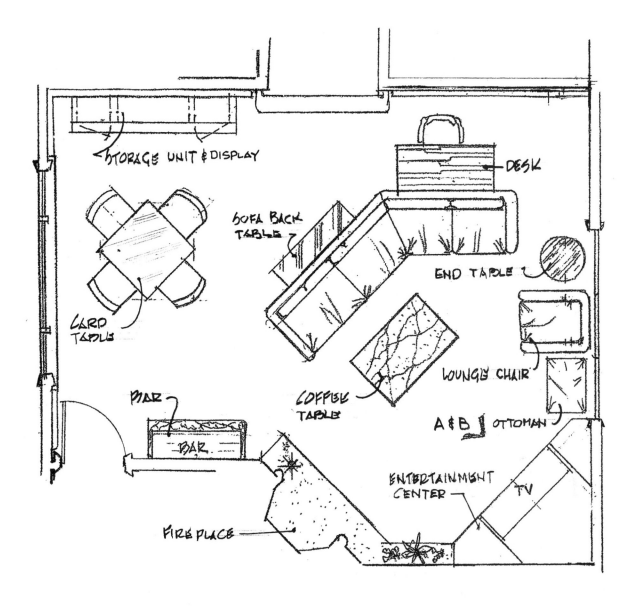

STORAGE UNIT & DISPLAY

DESK

SOFA BACK TABLE

END TABLE

CARD TABLE

LOUNGE CHAIR

BAR

COFFEE TABLE

A & B OTTOMAN

BAR

FIRE PLACE

ENTERTAINMENT CENTER

TV

FLOOR PLAN OF FAMILY ROOM

$$\frac{1}{4}" = 1'\text{-}0"$$

Illustration H–1

DRAFTING TOOLS USED TO PRODUCE DRAWINGS

TRIANGLES

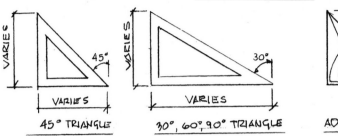

45° TRIANGLE 30°, 60°, 90° TRIANGLE ADJUSTABLE TRIANGLE

THE ABOVE SHOWN TRIANGLES ARE MADE MOSTLY FROM TRANSPARENT
PLASTIC AND ARE USED FOR DRAWING VERTICAL LINES

PARALLEL BAR OR "T" SQUARE

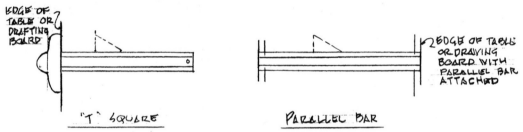

"T" SQUARE PARALLEL BAR

THE PARALLEL BAR AND "T" SQUARE ARE MOVABLE AND ARE USED TO PRODUCE
HORIZONTAL LINES; THEY ALSO ARE USED TO SEAT TRIANGLES FOR VERTICAL LINES

PLASTIC DRAWING TEMPLATES

MULTI-FUNCTION TEMPLATE FURNITURE TEMPLATE

THE ABOVE TEMPLATE IS USED THE ABOVE TEMPLATE IS USED
FOR DOOR SWINGS, CHAIRS, TABLES TO DRAW FURNITURE & CAN BE
ETC. PURCHASED IN VARIOUS SCALES

Illustration H-2

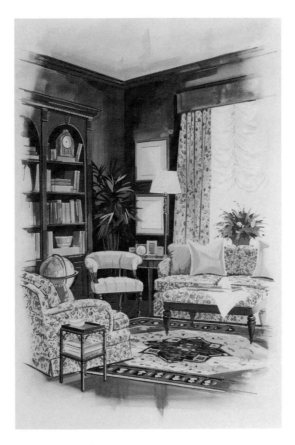

Plate F–1 English

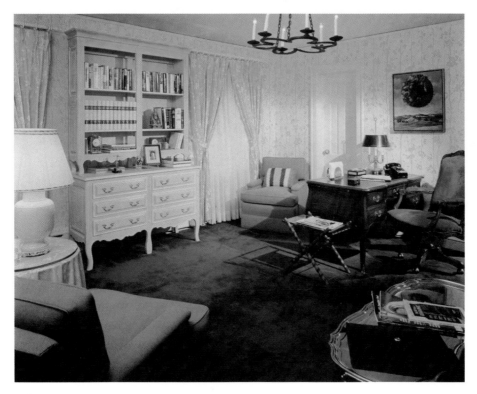

Plate F–2 Country French

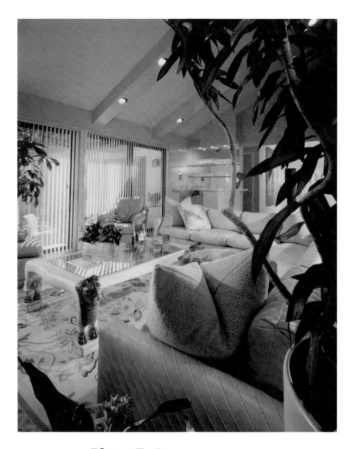

Plate F–3 Contemporary

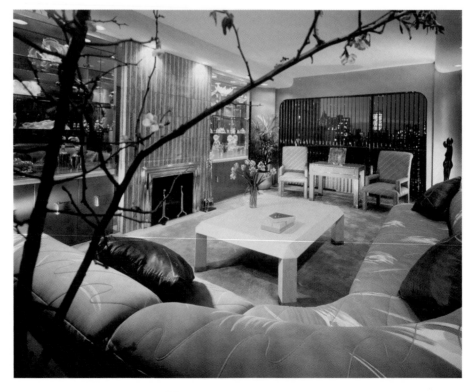

Plate F–4 Art Deco

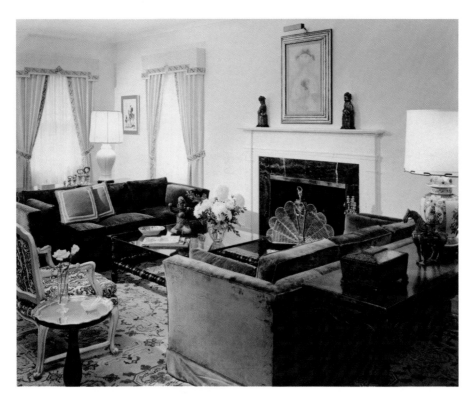

Plate G–1 Formal

Plate G–2 Casual

Plate G–3 Western American

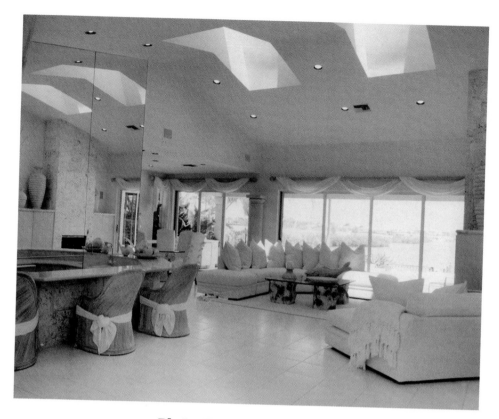

Plate G–4 Contemporary

Plate G–5 Country Casual

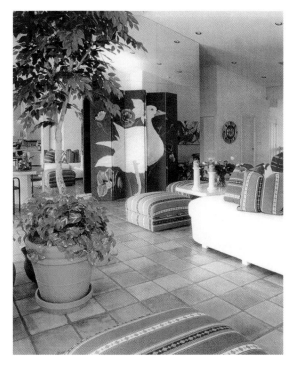

Plate G-6 Eclectic

Plate G-7 Oriental

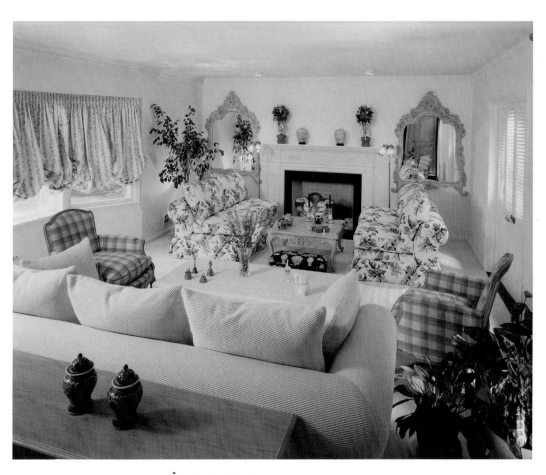

Plate O-1 Country French

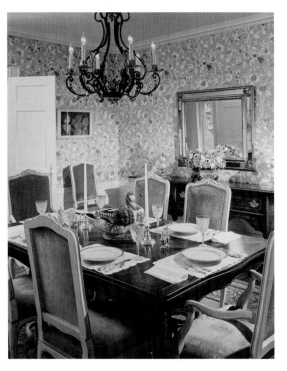

Plate O-2 Formal French

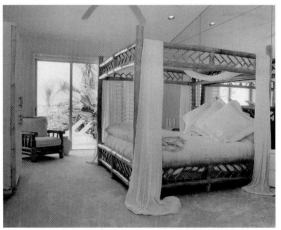

Plate O-4 Country Casual

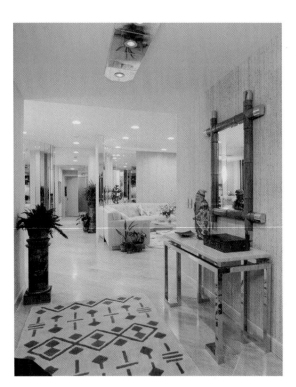

Plate O-5 Eclectic

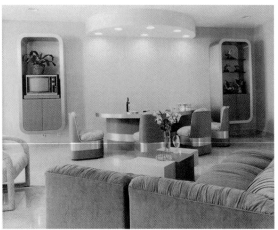

Plate O-6 Art Deco

Dining Room/Breakfast Room Questionnaire (Illustration I–1)[1]

Items

1. Is this area a dining room or breakfast area? ✔ Dining area

 ___ Breakfast area

2. Is it necessary for your dining table to open? ___ Yes ✔ No

3. If not, how many people do you want to seat? ___ 4–6 ✔ 6–8 ___ 8–10

4. If so, how many people do you want to seat? ___ 6–8 ___ 8–10

5. Do you want your dining room to have an area for ___ Storage ___ Display

 ___ Serving ✔ All 3

6. Would you like your dining chairs to include ✔ Host chairs

 ✔ Hostess chairs

 6 Side chairs

 ___ Arm chairs

7. What table shape do you want? ___ Round

 ___ Oval

 ✔ Rectangle

 ___ Square

 ___ Banquette

8. What table size do you want?

	4–6	6–8	✔ 8–10
Round	42″ or 48″φ	48″ or 54″φ	✔ 54″ or 60″φ
Rectangular	30″ × 60″	36″ × 72″	48″ × 84″
Square	48″	54″	60″
Oval	30″ × 60″	36″ × 72″	48″ × 84″

(In cases where extension leaves are used, table sizes should be determined by length of the room, making sure to leave enough room for passage between walls, buffets, display units, and chairs.)

[1] In addition to the floor plan for the dining room, master bedroom, children's room, and home office, we also have shown elevations. We feel these will clarify different areas of the floor plans. (Further explanation and illustrations of elevations and renderings are in the conclusion of this section.)

DINING ROOM FLOOR PLAN & ELEVATIONS

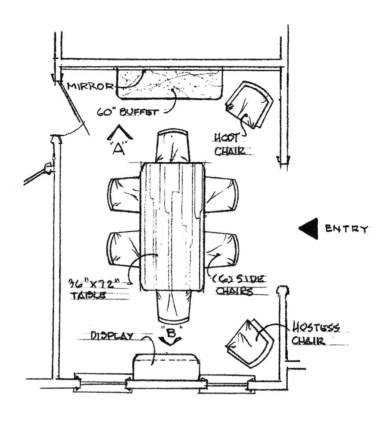

DINING ROOM

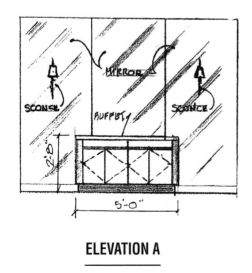

ELEVATION A

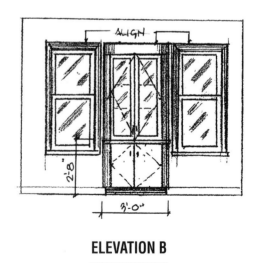

ELEVATION B

Illustration I–1

Master Bedroom/Guest Bedrooms/Sitting Room Questionnaire (Illustration J–1)

Items

1. Which room are we working on?
 - ✔ Master bedroom
 - ___ Guest bedroom
 - ___ Sitting room

2. What size bed do you want for this room?
 - ___ King 78″
 - ✔ Queen 60″
 - ___ Single 36″–39″
 - ___ Double 48″–54″

3. Do you like poster beds? ___ Yes ✔ No

4. Do you want a TV in your bedroom? ✔ Yes ___ No
 Do you want book storage? ✔ Yes ___ No

5. Would you like some seating in your bedroom? ✔ Yes ___ No

6. Do you like armoires? ✔ Yes ___ No

7. Would you like a desk in your bedroom? ✔ Yes ___ No

8. Do you want built-ins? ✔ Yes ___ No

9. Do you need a dresser? ✔ Yes ___ No

10. Do you need a man's highboy? ___ Yes ✔ No

11. Would you like any other items—such as:

 Chaise longue ✔ Yes ___ No

 Night tables ✔ Yes ___ No

 Vanity ✔ Yes ___ No

MASTER BEDROOM FLOOR PLAN & ELEVATIONS

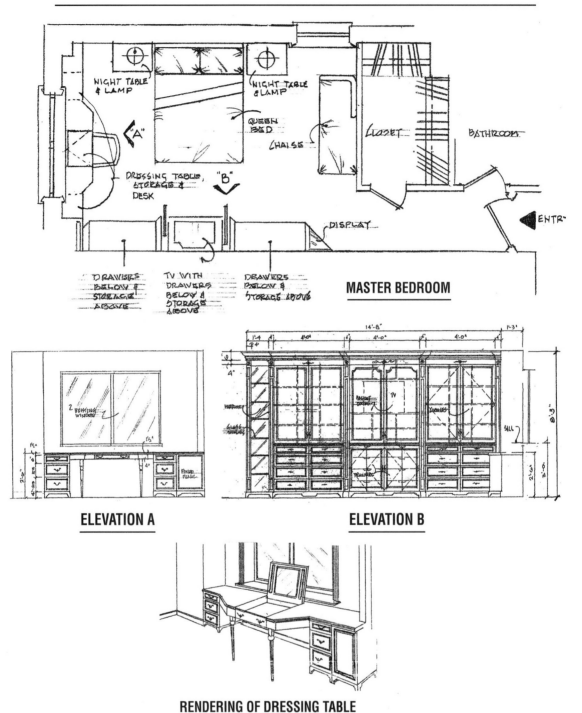

MASTER BEDROOM

ELEVATION A

ELEVATION B

RENDERING OF DRESSING TABLE

Illustration J–1

Children's Room/Teenager's Room/Boy's-Girl's Nursery Questionnaire (Illustration K–1)

Items

1. What ages are the children?

 ____ Pre-Teens

 ✔ Teens

 ____ Infants

 ✔ Boys

 or ✔ Girls

2. Would you like to include

 ✔ Desk and desk chair

 ✔ Bookshelves

 ✔ Storage area

 ✔ TV

 ✔ Stereo

 ✔ Computer

 ✔ Dresser

 ____ Other

 ✔ Seating

3. Would you like a Murphy Bed in this room?

 ____ Yes ✔ No

4. What size bed would you like?

 ____ Crib

 ____ Queen—60"

 ____ Double—54"

 ____ Single—36"–39"

 ✔ High-riser

 ____ Bunk beds

TEEN BEDROOM FLOOR PLAN & ELEVATIONS

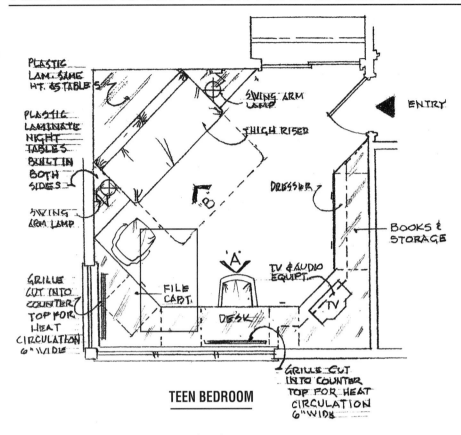

PLASTIC LAM. SAME HT. AS TABLES

SWING ARM LAMP

THIGH RISER

ENTRY

PLASTIC LAMINATE NIGHT TABLES BUILT IN BOTH SIDES

DRESSER

BOOKS & STORAGE

SWING ARM LAMP

TV & AUDIO EQUIPT.

FILE CABT.

'A'

GRILLE CUT INTO COUNTER TOP FOR HEAT CIRCULATION 6" WIDE

TV

DESK

GRILLE CUT INTO COUNTER TOP FOR HEAT CIRCULATION 6" WIDE

TEEN BEDROOM

ELEVATION A

ELEVATION B

Illustration K-1

Home Office Questionnaire (Illustration L–1 and L–2)

Items

1. Is this room to be used as a ____ Full-time office
 ✔ Part-time office

2. Do you need an area for built-in ✔ TV
 Desk/cabinetry for built-in ✔ Telephone
 ✔ Computer/printer
 ✔ Storage
 ✔ Bookshelves
 ✔ Fax machine
 ✔ File storage

3. Would you like seating in this room to be a ✔ Sleeper sofa
 ____ Regular sofa

4. Would you like a recliner? ____ Yes ✔ No
5. Would you like a pull-up chair for the desk? ✔ Yes ____ No

HOME OFFICE FLOOR PLAN

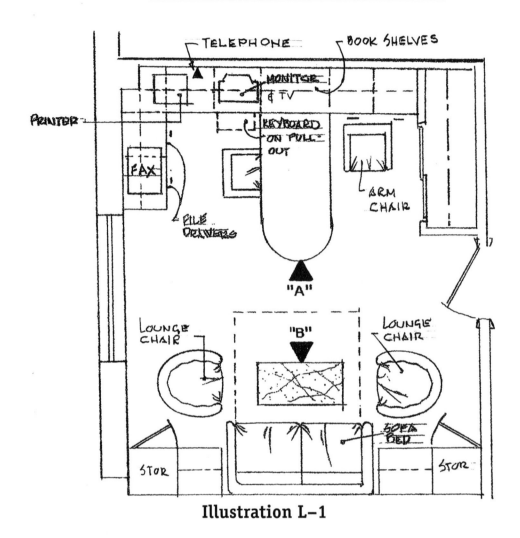

Illustration L–1

HOME OFFICE FLOOR PLAN ELEVATIONS A AND B

A AND B

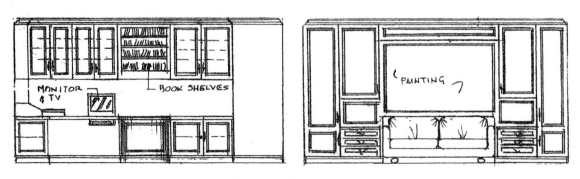

Illustration L–2

CONCLUSION

We have presented these various floor plans (Illustrations H–1, I–1, J–1, K–1, and L–1) so you can see how they relate to the answers given to the various questions and so you can learn how different rooms can be developed and created in a similar manner.

Please be sure to examine our illustrated floor plans carefully (Illustrations H–1, I–1, J–1, K–1, and L–1), taking note of the excellent traffic patterns in each. Using the 1/4″ = 1′ scale and your scale ruler, measure the dimensions we have allowed for the traffic areas. This is of paramount importance in creating any floor plan.

We have taken the floor plan two steps further with an illustration of an elevation (Illustrations M–1 and M–2) and renderings of this plan (Illustration N–1). These illustrations will enable you to see an elevation of one wall as well as a three-dimensional version of your plan, and will be helpful when you are working on the decorating section of this book. However, these steps involve more technical skills and expertise than can be outlined here; these usually can be developed through experience and the use of AutoCAD. We included these drawings in this section so you might see how they relate to the floor plan we have created.

It should be emphasized that the floor plan is always the basis of all good design work and should always be the first step for any interior design project. No elevation or rendering can develop properly without the floor plan first.

Now that you have learned how to execute the floor plan, you can take this map and proceed to Decorating Your Room, the second section of this book. Although this section might appear to be less serious and disciplined than the technical section, the following pages will show that this is not the case. To create a truly aesthetic environment you must understand the information in the steps given for decorating your room. With your floor plan to refer to constantly and the process outlined in the coming pages, you can go on to confidently develop your decorating scheme.

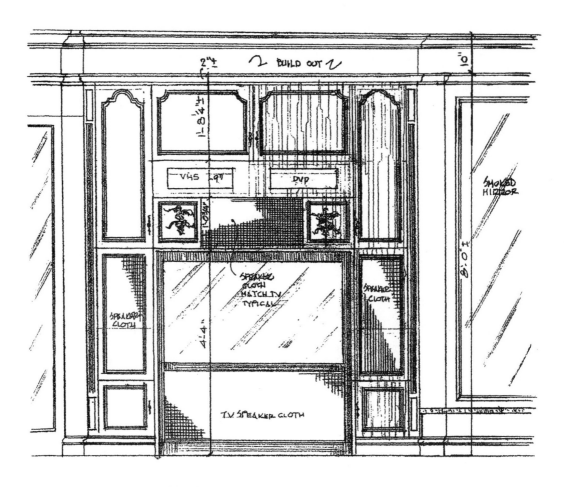

ELEVATION "A" – TV/AUDIO UNIT WITH DOORS
1/2" = 1'-0"

Illustration M–1

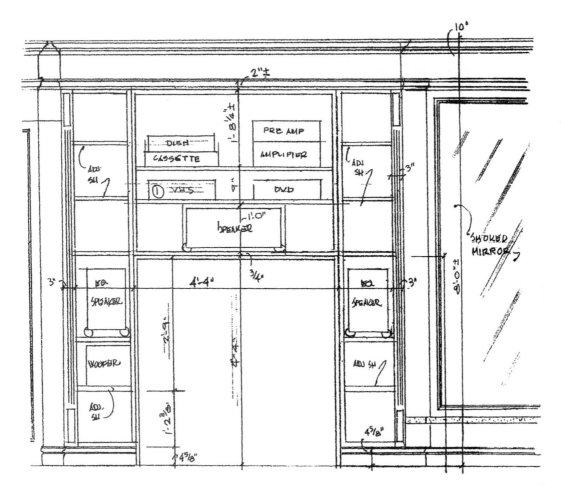

ELEVATION "B" – TV/AUDIO UNIT WITHOUT DOORS

1/2" = 1'-0"

Illustration M–2

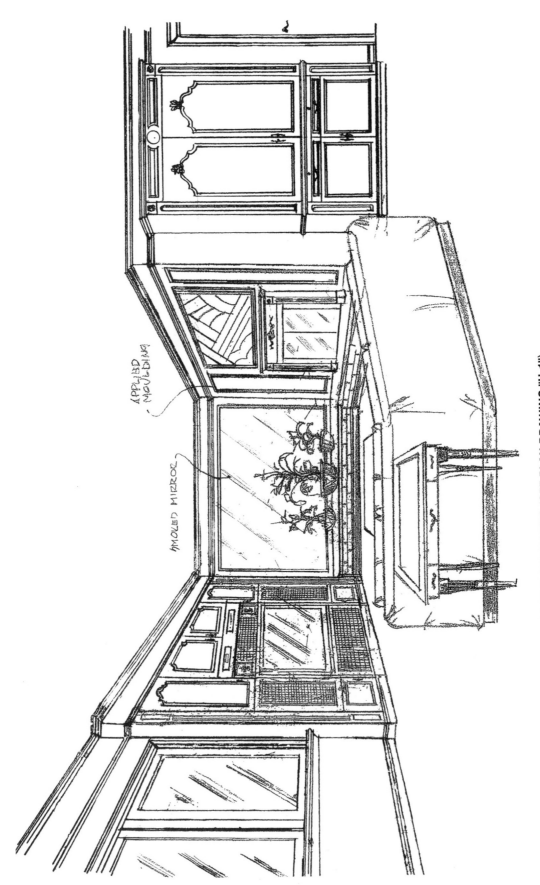

APPLIED MOULDING

SMOKED MIRROR

FAMILY ROOM RENDERING (SEE PLAN DRAWING "H-1")

AND ELEVATIONS "A" & "B" ON DRAWING "M-1" & "M-2"

Illustration N-1

36

DECORATING YOUR ROOM 2

With your floor plan in hand, you can commence work on the decoration of your project. Although you may think the decoration of your project is spontaneously artistic, nothing is further from the truth.

The decoration of any room involves a number of distinct and separate elements. The integration of all these elements and the knowledge of how they interact with each other to create a room's ambiance must be studied very carefully. To do really exciting artistic work one must always understand why one does something. The end result just doesn't appear out of nowhere; it is the result of a distinct, logical thought process. Although using these elements is not as technical and exacting as $1 + 1 = 2$, each one is important to the aesthetic success of your room.

The following section outlines these various elements, detailing what they do, how you should use them, and what their benefits, strengths, and weaknesses are. Before we proceed to the elements themselves, however, we will start with a list of suggested questions pertaining to your likes and dislikes. These must be answered in order to ascertain how to proceed with the room's decoration. This step in decoration is as important as it is in the design of the floor plan. The questions will assist you in narrowing the large, vague area of decoration to more specific, concrete answers, thus giving you a more secure foundation from which to work.

General Questions Pertaining to Decoration[2]

1. Would you like your rooms to be
 - ____ Formal
 - ✔ Casual

2. Do you like your rooms to be
 - ____ Colorful
 - ✔ Monochromatic

3. Do you like your rooms to be
 - ✔ Serene
 - ____ Busy

4. Do you prefer fabrics that are
 - ____ Pattern
 - ____ Textured
 - ____ Solid
 - ✔ Or all

5. Do you prefer fabrics that have
 - ____ Large florals
 - ____ Small florals
 - ✔ Both
 - ____ Neither

[2] These questions are answered as they apply to Illustration H–1 in Section 1.

6. Do you like fabrics that are

 ____ Vinyls
 ✔ Leathers
 ____ Both

7. Do you like fabrics that are

 ____ Stripes
 ____ Plaids
 ____ Checks
 ____ Small prints
 ✔ All

8. For the walls of the rooms would you prefer

 ____ Wallpaper
 ✔ Paint
 ____ Paneling

9. For the walls of the rooms, do you like

 ____ Pattern
 ✔ Texture

10. For the floors of these rooms would you prefer

 ✔ Wall-to-wall carpets
 ____ Area rugs
 ____ Wood floors
 ____ Tile
 ____ Marble
 ____ Vinyl

11. For your window treatment would you prefer

 ____ None
 ____ Decorative treatment
 ✔ Privacy treatment

12. For your bedrooms (master, children, guest) do you need darkness or privacy at windows?

 ✔ Yes
 ____ No

13. Do you want a home office, den, or study to be masculine in ambiance?

 ✔ Yes
 ____ No

14. What type of covering would you like for desk chairs and recliner(s) for a study/den/home office?

 Desk chair
 ✔ Leather
 ____ Fabric

 Recliner
 ✔ Leather
 ____ Fabric

15. Do you like to use antiques? ____ Yes ____ No

 period furnishings? ____ Yes ____ No

 contemporary furnishings? ____ Yes ____ No

 eclectic furnishings? ✔ Yes ____ No

These general questions and their answers attempt to narrow the incredibly large area of decoration and are invaluable to you when embarking on your decorating project. However, they must be used in connection with the elements in the following three sections: Furniture—Choosing an Ambience and Style; Color Plan; and Fabrics. This integration is the foundation of your ultimate decorating scheme.

FURNITURE: CHOOSING AN AMBIANCE AND STYLE

Choosing furniture is the first step and most important element in the decoration of your room. Furniture is considered the bones or structure of your room. Just as your cheekbones, eyes, and nose create the character of your face, furniture selections create the character of your room.

The first step in identifying the furnishings to be selected is, of course, to choose a period or style which will influence the ambiance of the room. On pages 15 to 21, as part of the general questions for designing a room, we used photos to illustrate various styles (Illustrations G–1 to G–7) so that you would have a visual image of these styles.

In this section we will look at these styles with the visual illustrations again, but there will be one very important difference: a **choice must now be made** by you or perhaps your customer. Without this choice the development of your decoration scheme cannot begin. To begin with, the styles in the following table are presented so that a definite answer about decoration can be established.

The photos on the following pages illustrate the styles and furnishings listed in the table (Illustrations O–1, O–2, O–3, O–4, O–5, and O–6). We also have included various specific types of furniture (Illustrations O–7 and O–8) that define different periods and types of furniture.

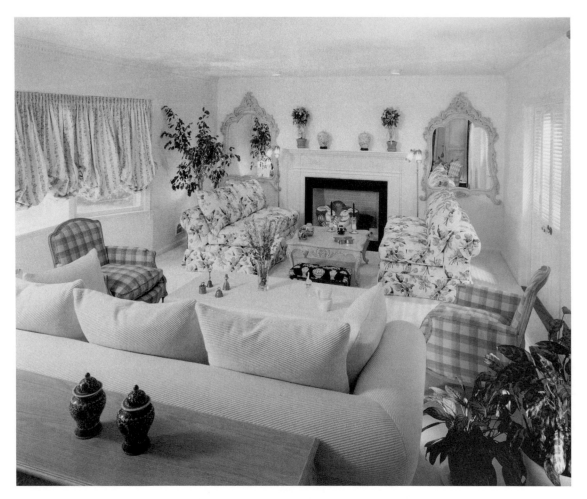

Illustration O–1 Country French

TABLE OF STYLES

Period or Styles[3]	Furniture
Western American	American Frontier
	American Ranch
Early American	Shaker
	Mission
	Windsor chairs
	Hitchcock chairs
	Pennsylvania Dutch
Traditional English	Duncan Phyfe
	Queen Anne
	Chippendale
	Hepplewaite
	Sheraton
	Adams
Formal English	Regency
Country French (Illustration 0–1)	French Provincial
Formal French (Illustration 0–2)	Louis XIII
	Louis XIV
	Louis XV
	Directoire
	French Regency
Contemporary (Illustration 0–3)	Biedemeier
	Art Deco
	Chinese Chippendale
	Simple Sheraton
	Sectionals—upholstery and wood pieces
Country Casual (Illustration 0–4)	French Provincial
	Early American
	Contemporary
Eclectic (Illustration 0–5)	Biedemeier
	Modern—Danish
	Swedish
	Finnish
	Traditional
	Contemporary
Art Deco (Illustration 0–6)	Contemporary
	Avant-garde
	Art Deco (1908–1930)
	Eclectic
Oriental	Works well with Provincial English

[3] Modern is an influence rather than a rigid style.

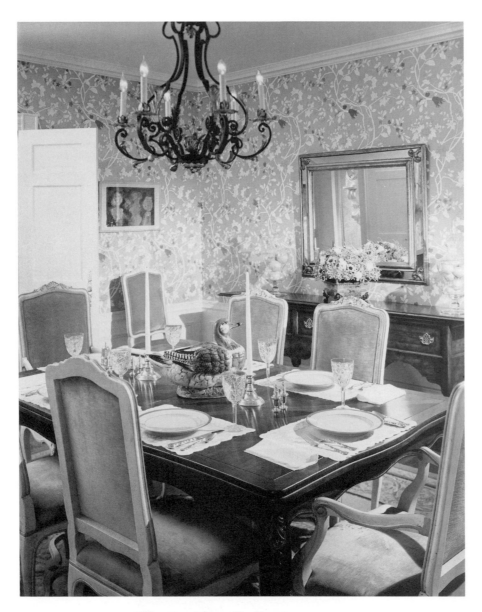

Illustration 0–2 Formal French

Many books have been written with drawings and descriptions of furniture, their various styles, and their historical data. In this book we are only going to show the most pertinent styles in today's interior design world that are applicable in helping you and influencing you on your path to establishing and formulating a decorative scheme. Some of the furniture styles we have illustrated are self-explanatory; we shall suggest the circumstances in which we feel these furniture styles can be used to best advantage.

It is essential that the scale of the furniture that is selected be in proper proportion to the room's dimensions, ceiling height, and traffic patterns. The total number of furnishings used should be in proper proportions

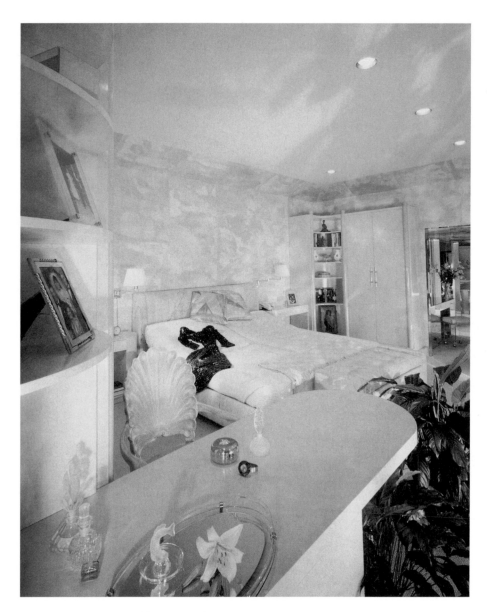

Illustration O–3 Contemporary

as well. Be especially careful about upholstered furniture because of its depth. Any upholstered piece (sofas, chairs, etc.) in excess of 38" in depth can overwhelm small spaces and destroy proper traffic patterns.

To assist you further, we offer the following suggestions of various ways that furniture styles can be integrated into your decoration scheme with the greatest success.

The first thing you must understand regarding these periods and styles of furniture is that in today's world formality is almost nonexistent in design work. As a result, the most formal styles, such as Formal French or Formal English, are virtually absent from most homes. The formal living room or dining room used only for adult entertaining or "company" is not a phenomenon of today's society. Therefore, those types of furniture are rarely specified for most people interested in a handsome, functional home.

Because of this change in lifestyle, there is a mixture of furniture types that includes more traditional wood pieces with very comfortable, generously stuffed contemporary upholstery. Period design chairs and

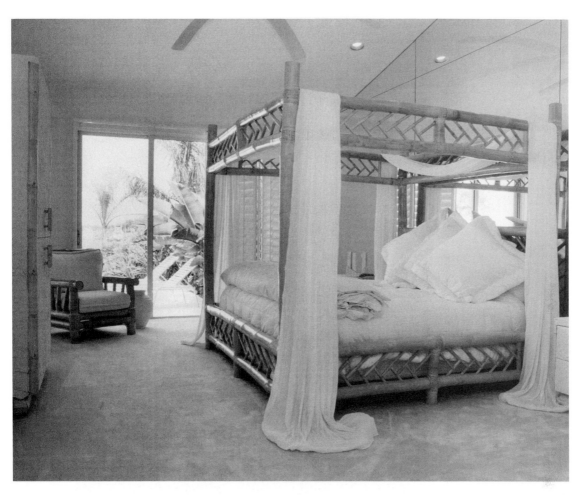

Illustration 0–4 Country Casual

wood pieces—whether Chippendale, Sheraton, Duncan Phyfe, or Country French—are easily mixed with contemporary upholstery and fabrics to create an eclectic, comfortable, handsome ambiance suitable for the lifestyles of the majority of today's homeowners. The various pieces of furniture illustrated here as examples of those styles can be combined in today's interiors with very comfortable, plump, contemporary upholstery. These combinations create a more informal ambiance than if the furniture was confined exclusively to the same period and style. Furthermore, styles such as Country French and Biedermeier are particularly effective in contemporary settings because of their charm and simplicity. In different ways, Chippendale, Duncan Phyfe, and Art Deco wood pieces also are appropriate with contemporary design schemes.

This mixture, the interplay and intermingling of styles and types of furniture, is effective whether reproductions or fine antiques are used. All result in an environment and ambiance compatible with the living modes and styles prevalent in today's ever-changing world.

With this overview of the various general styles and specific types of furniture, it should be apparent that with proper knowledge, a keen eye, and a floor plan, this very important element—furniture—can truly become the bones of your room. Because today's world changes so quickly, however, there are no set rules to follow. With the broad choices of furniture and styles offered to you, you will have great flexibility.

Illustration O–5 Eclectic

Illustration 0–6 Art Deco

Illustration O–7 Furniture Illustrations

LOUIS XV

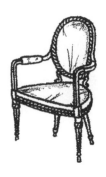

ADAM

SHERATON

FRENCH PROVINCIAL

WINDSOR

DUNCAN PHYFE

LOUIS XVI

Illustration 0-8 Furniture Illustrations

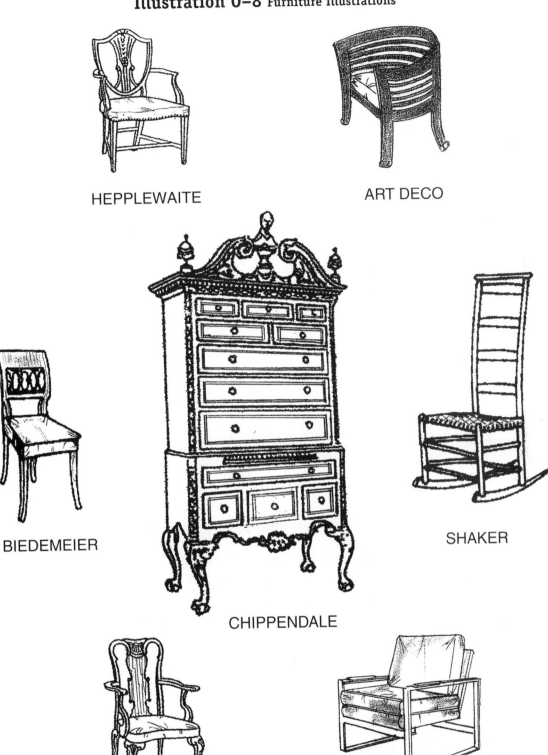

HEPPLEWAITE

ART DECO

BIEDEMEIER

CHIPPENDALE

SHAKER

QUEEN ANNE

CONTEMPORARY

COLOR PLAN

Color plays an incredibly important role in decorating a room. As small children, we are taught to identify individual colors and we react in different ways to bright, soft, dark, or muted colors. When decorating your room, you will want to use color effectively, whether it is for fabrics, walls, carpets, or the total ambiance. The following method will be invaluable to you in narrowing the choice of color preferences for yourself. These choices will enable you to develop your color palette or plan.

In order for you to determine color choices and combinations of color choices, the following specific questions should be posed with very specific color examples (Illustrations P–1, P–2, P–3, and P–4) so there is no confusion in what one person might call a particular color or attribute to that color (see Sample P—grass green). If presented in this manner, with no name attached, it is less likely that you (or perhaps your client) will attach other attributes to the specific color that you are viewing.

To begin the color selection process, ask yourself to do the following:

A. Check off 3 of the 25 colors (Illustrations P–1 and P–2 on the color insert) that you like best in order of your preference (1, 2, 3).

B. Check off 3 of the 25 colors that you dislike most in order of your dislike (4, 5, 6).

Write your preference (1, 2, 3) for the colors on the palettes themselves. Do the same with those you dislike (4, 5, 6) so you have a definite handle on what you prefer and don't prefer.

Go through the same process with the color combinations using Illustrations P–3 and P–4:

C. Indicate the three combinations of color presented here (Illustrations P–3 and P–4) that you prefer in order of preference (7, 8, 9).

D. Indicate the three combinations of color presented here that you least prefer (10, 11, 12).

Again, write these preference numbers directly on the palettes. In addition to establishing these color preferences, two more questions should be repeated from the General Information Questions that are distinctly pertinent to color:

E. Do you like your rooms to be ____ Colorful

 ____ Monochromatic

F. Do you like your rooms to be ____ Serene

 ____ Busy

You now have the information about the most important choices for yourself in relation to color and the overall atmosphere or ambiance that is preferred. You are also in an excellent position to determine the actual makeup of your color palette and plan, which, of course, will reflect your preferences (or perhaps those of your client).

To close this section on color, we provide an overview that will describe some of the most commonly used combinations, the effects of various colors, and how colors change and influence the ambiance of your rooms.

Colors affect the ambiance of rooms because they affect our emotional responses. Monochromatic schemes and more colorful combinations have different effects on our emotions, so they will produce different "feels" for rooms.

Monochromatic combinations are serene. These combinations use one or two very similar colors, such as bone/light beige as seen in Illustration P–3's center illustration and in the two light colors in the upper left (off white/white and bone). They lack any strong additional colors, creating a calm ambiance. Monochromatic schemes have been and continue to be the most popular in today's design world. In addition, they create a wonderful background for more colorful art and accessories. Although not as exciting or stimulating as the use of strong, vibrant colors, many people find these monochromatic ambiances most suitable and soothing for their homes, especially because of the very difficult, hectic, and often frightening world outside. The soft shades of peach in Illustration P–1 (lower left middle and lower right sections) are also very popular today for exactly the same reasons. These are especially suitable for bedrooms because of the serene ambiance they create. Combinations of soft pinks and greens, although not monochromatic, create the same, quiet ambiance and are also popular, especially for bedrooms.

Plate P–0

Plate P–1 Color Palette

Plate P–2 Color Palette

Plate P–3 Suggested Combination of Colors

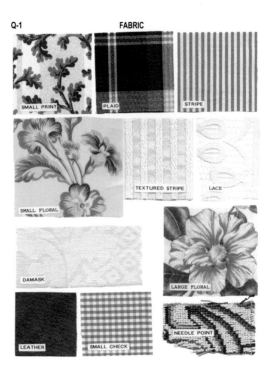

Plate P–4 Suggested Combination of Colors

Plate Q–1 Fabric Samples

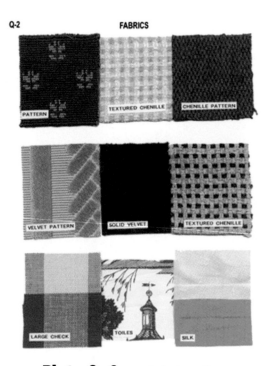

Plate Q–2 Fabric Samples

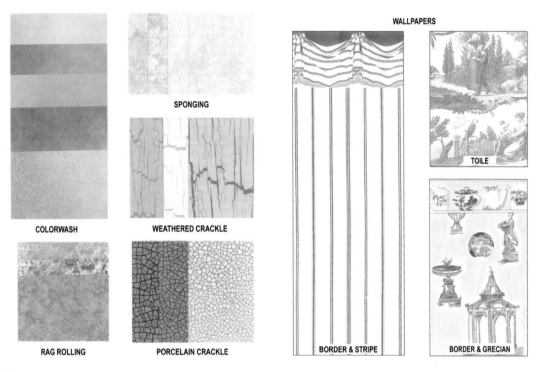

COLORWASH

SPONGING

WEATHERED CRACKLE

RAG ROLLING

PORCELAIN CRACKLE

Plate R–3 Porcelain Crackle, Rag Rolling, Sponging, Weathered Crackle, Color Wash

WALLPAPERS

BORDER & STRIPE

TOILE

BORDER & GRECIAN

Plate R–4 Wallpaper Samples

WALLPAPERS

BORDER & FRENCH

BORDER & ORIENTAL

Plate R–5 Wallpaper Samples

WALLPAPERS

BORDER & TRELLIS

BOOK WALLPAPER

Plate R–6 Wallpaper Samples

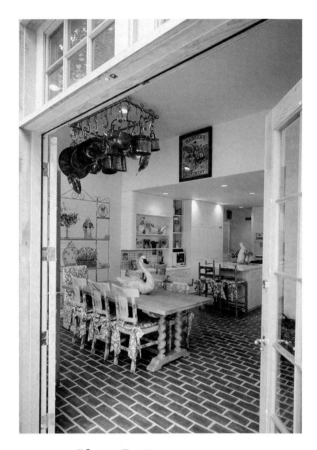

Plate R–7 Trompe L'oeil

Plate R–8 Faux-Lizard Vinyl Wall Covering

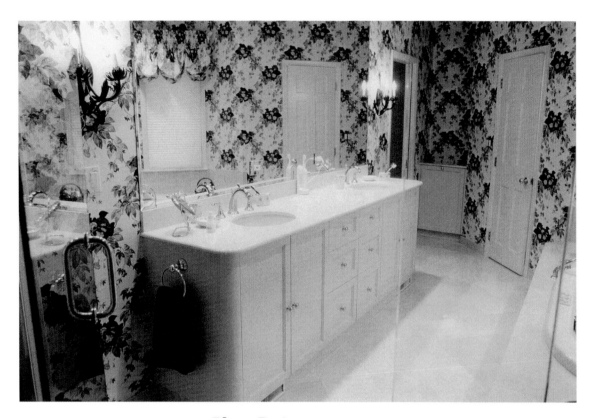

Plate R-9 Paper in Bath

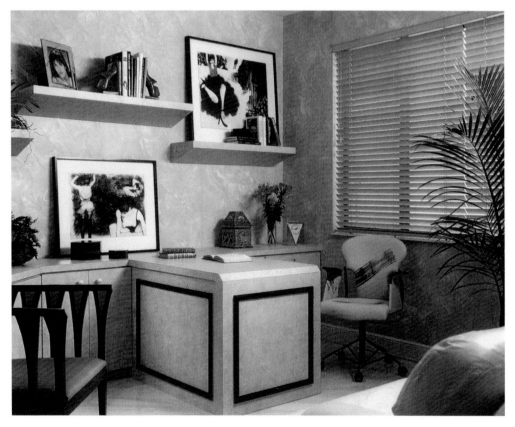

Plate R-10 Marbleized Paper in Study

Plate R–11 Wood Paneling

Plate R–12 Mirror–Dining Wall

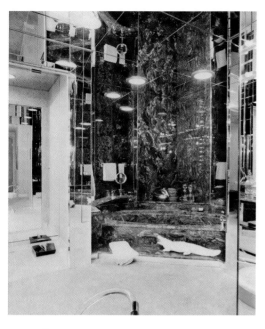

Plate R–13 Marble on Walls

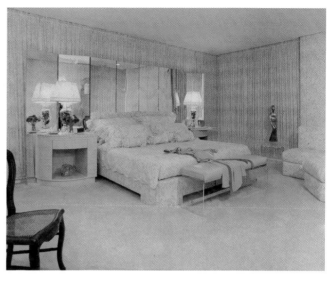

Plate S–1 Wall-to-Wall Carpet

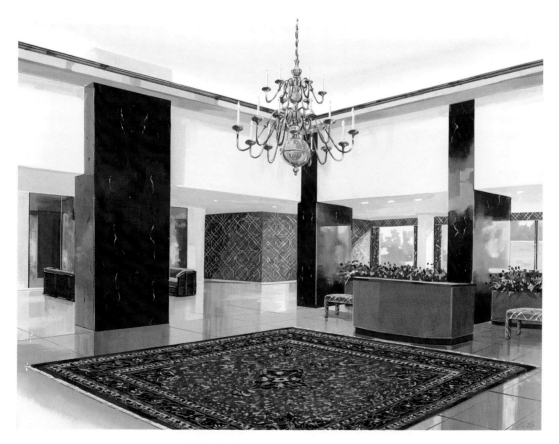

Plate S–2 Area Rugs–Lobby

Plate S–3 Area Rugs–Living Room

Plate S–4 Marble Pattern Floor

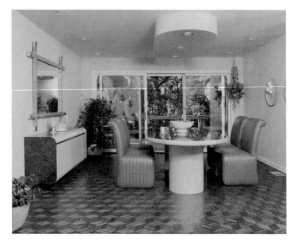

Plate S–5 Wood Parquet Floor

Plate T–3 Sheer Installations–Double-Height Ceilings

Plate T–4 Balloon Shade Valance

Plate T–5 Theatrical Wall Curtain

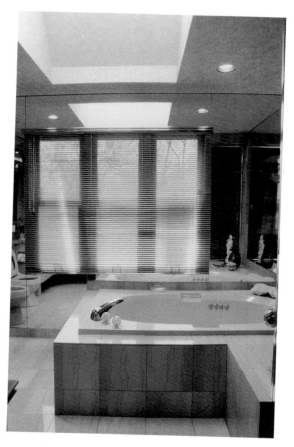

Plate T–6 Venetian Blind in Bath

Plate U–4 Chandeliers

Plate U–5 Track Fixtures

Plate U–6 Sconces in Dining Area

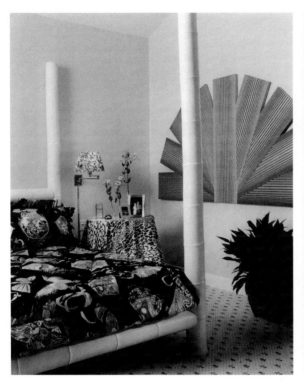

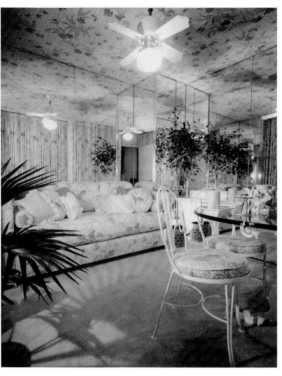

Plate U–7 Swing-Arm Lamps

Plate V–1 Mirror—Small Room—Two Walls

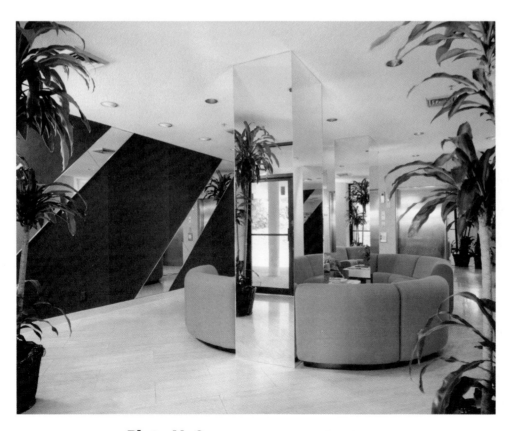

Plate V–2 Mirror—Lobby with Columns

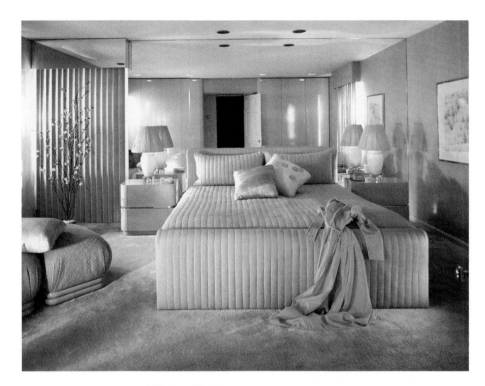

Plate V–3 Mirror—Bedroom

Plate V–5 Fireplace

Plate V–6 Columns—Showhouse Room

Plate V–7 Ceiling Soffit

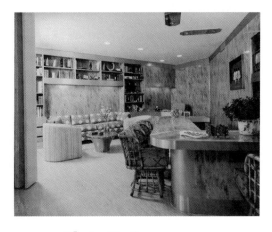

Plate V–9 Built-ins

Plate W–1 Pillows and Wall Sculpture

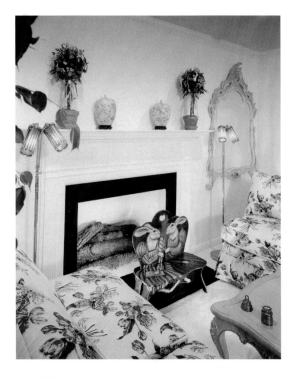

Plate W–3 Framed Mirrors and
Accessories

Plate W–4 Painting

Shades of blue and white, which are very traditional and familiar to all of us, are appealing to many because of their familiarity. When this combination is used with yellow, it creates an exciting, yet soothing, aura. For many, shades of yellow and white create a bright, happy atmosphere and are often combined with green. Again, this combination is familiar and comfortable.

The more colorful combination of red, black, and shades of white or bone is extremely successful in all its forms, and it usually is suggested for a more contemporary setting. Red, although much more striking and stronger than pastels, can create a warm, inviting ambiance. It also can be used with shades of gray, and, of course, gray is identified with masculine environments such as studies, dens, and offices.

The multicolor scheme of a flower garden—cerise, lavender, blue, orange, yellow, green, and red—creates a happy, bright ambiance in your rooms.

In the preceding discussion of combinations, we hardly have touched upon all the possibilities, identifying a small selection of popular combinations, the ambiance they create, and the emotional reactions they generate. Although color and its successful application really cannot be taught, with experience, innovation, and creativity you will discover many additional wonderful combinations that you will successfully use for your decorating palette.

FABRICS

Now that you have an understanding of furniture as the bones of your room and color as the immediate visual element, the next important element to discuss is fabrics and how fabrics are integrated into your decorating plan.

Fabrics are the tactile, textured element in decoration. Fabrics can give your room a feeling of warmth or coolness. The many patterns and shadings of fabrics can create lightness or darkness, smoothness or roughness, and shiny or matte surfaces.

One of the most interesting aspects of this element is that color is involved in all the types of fabrics available. Because color is present in all fabrics, fabrics create an immediate and strong visual impact in conjunction with the other elements that have already been discussed and with the elements in the next section—the walls, floors, and windows. All of these are the basis of your decoration plan and result in a strong visual impact that is responsible for the room's atmosphere and ambiance.

A number of pointed questions should be asked of yourself and possibly your clients and customers concerning fabrics. These questions follow, but remember to include questions pertaining to fabrics that appeared in the General Questions for decorating as well.

Please check one or more

1. Do you prefer fabrics that are

____ Pattern
____ Textured
____ Solid
____ Needlepoint
____ Velvet
____ All

2. Do you prefer fabrics that have

____ Large florals
____ Small florals
____ Toiles

3. Do you like fabrics that are

____ Vinyls
____ Leathers
____ Suede

4. Do you like fabrics that are

 ____ Stripes
 ____ Plaids
 ____ Check
 ____ Small prints
 ____ All

5. Doyou like fabrics that are

 ____ Cotton
 ____ Silk
 ____ Linen
 ____ Synthetic
 ____ All

6. Do you like

 ____ Sheers
 ____ Lace
 ____ Damasks

With the answers to these questions you will be able to focus more accurately on your likes and dislikes, enabling you to formulate your decoration plan and select various fabrics to carry out your scheme to suit your needs, the function of the room, and its ambiance. While executing this plan, it is paramount to remember at all times that your decorating plan should reflect your needs and wants. Our aim in this book is to assist you in interpreting your desires and needs for the specific rooms to be decorated (i.e., playroom, living room, den, bedrooms, etc.). Your work should always reflect these requirements.

If you choose to become a professional, however, new ideas, thoughts, and of course fabrics can be introduced. With a creative presentation by you, you can show that the use of such new fabrics could enhance the functional requirements and the ambiance of one's home.

No presentation of fabric selections is ever possible with small swatches. It is imperative, therefore, for you to acquire samples approximately $12'' \times 12''$ in size for your presentation. (Most fabric showrooms lend that size sample on request.) This size of sample allows one to actually see, touch, and appraise the fabrics for color, texture, lightness, darkness, the mood they convey, and how they may be integrated into your design scheme. Without these large samples, it is virtually impossible to gauge the intermingling of various surfaces or the durability, wearability, and cleaning properties of fabrics—all important factors in making decisions on where and how fabrics are to be used.

Trimmings, such as fringe, tassels, decorative gimps, borders, tie-backs, ropes, embroideries, and monograms, also can be used in conjunction with fabrics. These trimmings play an important role in customizing not only the fabrics, but your entire installation.

Now that you have an idea of the important impact fabrics have on any decorating scheme, let's take a look at some of the choices in fabrics. Please refer to Illustrations Q–1 and Q–2 as we enumerate these various types of fabrics and their applications.

The choices in fabric grounds are: cotton (see the cotton damask in Illustration Q–1), silk (Illustration Q–2; silk is more costly and far less durable than cotton), linen (creases easily but creates a certain texture that is desirable for certain types of fabrics), and synthetics (very popular because of properties for easy maintenance, and the cost is usually most reasonable).

Large floral prints (Illustration Q–1; see Illustration W–3 as well), small floral prints (Illustration Q–1), and toiles (Illustration Q–2) usually are printed on cotton or linen grounds. These are popular fabrics and often are quilted either in their entirety or outlined in certain areas to increase wearability for upholstery pieces. Large and small florals can easily be combined with stripes (Illustration Q–1) and checks (Illustration Q–1) as well as texture fabrics. These are particularly suitable for window installations as well. Toiles (Illustration Q–2), particularly in shades of red, blue, green, and yellow, are fashionable at this time for everything from living and dining areas to bedrooms.

Fabrics that are textured, such as chenilles (solid, or textured, and patterned), solid velvet and velvet pattern (Illustration Q–2), and needlepoint (Illustration Q–1), are all substantial in thickness and weight. These primarily are used for upholstering and have strong wearability and cleaning properties. They are the

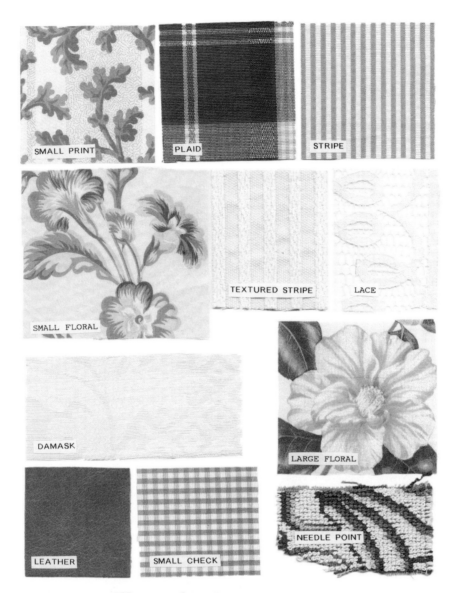

Illustration Q–1 Fabric Samples

principal types of fabrics for many hard-maintenance areas. They are popular in today's design world and readily available in the marketplace.

Leathers (Illustration Q–1), suedes, ultra-suedes, and vinyls (synthetic leather look-alikes) consistently are specified for masculine areas (i.e., dens, study, home offices, family rooms, offices, and commercial spaces). Tanning procedures have become so modern in technique that leathers have decreased in cost substantially, and they are increasingly used in all those areas mentioned previously. People also like to use leather because they like the feeling of relaxation, informality, and luxury this material creates.

Stripes in all their forms—narrow (Illustration Q–1), textured (Illustration Q–1), velvet pattern (Illustration Q–2), and wide-printed (Illustration Q–4)—on fabrics such as cotton, linen, and silk also have been and continue to be combined with almost any and all prints. These are a perfect tool to complete fabric selections for your decorating scheme. Small checks (Illustration Q–1), small prints (Illustrations Q–1 and

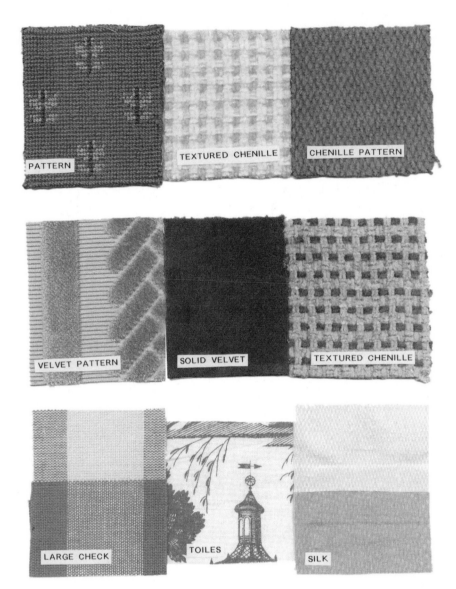

Illustration Q–2 Fabric Samples

Q–3; see Illustration U–7 as well), and large checks (Illustration Q–2) all fit into the same category and can be used interchangeably to complete a fabric scheme.

The last category we shall mention is sheers, such as the lace in Illustration Q–1. These casements come in widths from 54″ to 118″ or 130″; the largest sizes are especially suitable because fewer seams are necessary for most applications.

With this short overview, we have barely touched upon all the fabrics available, but we hope that with this foundation you will explore all the sources and possibilities available to you, so you may be especially creative in your selections and ultimately enrich your decoration plans.

Illustration Q–3 Fabric—Small Print

Illustration Q–4 Fabric—Stripe

THE ROOM'S "SHELL"

Now that you have designed the floor plan and you have determined the needs for the furniture, color plan, and fabrics, you are ready to actually decorate the room.

The next important elements in decorating a room are

- wall treatments (Illustrations R–1 and R–2),
- floor coverings, and
- window treatments.

These three elements are called the "shell" or "background" of the room and are vital for setting the stage for all the decorative elements to be integrated and utilized in creating the room and its environment.

PAINT, WALLCOVERING AND FLOORING NUMBER PLAN

$\frac{1}{4}'' = 1'-0''$

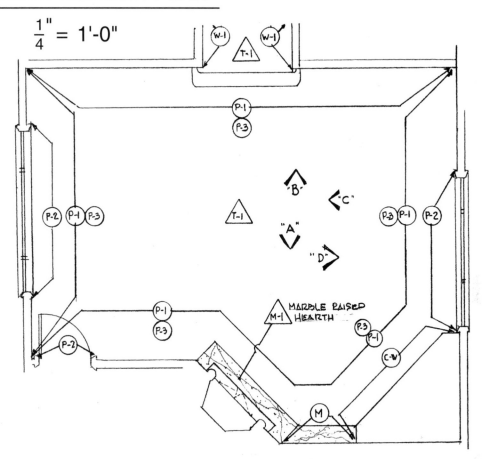

PAINT AND WALLCOVERING LEGEND

	MANUF.	NUMBER	COLOR	FINISH	REMARKS
P-1	BENJ. MOORE	#BJ 1201	OFF WHITE	SEMI-GLOSS	WALLS & CEILING
P-2	BEN J. MOORE	#BJ 1201	OFF WHITE	GLOSS	JAMBS, DOORS & SILLS
P-3	CABINET WORK	———	WHITE OAK	STAINED	CROWNS & BASE
C-W	CABINET WORK	———	WHITE OAK	STAINED	WALL UNIT
W-1	KRAVITS	#K 4202	—	VINYL	12" REPEAT, 54" WIDE
M-1	MIRROR	—	SMOKED	—	———
PL	PANELLING	—	—	—	BY CABT. CONTRACTOR

FLOORING

C-1	STARK	#5170	OFF WHITE BERBER	—	WALL TO WALL CARPET
T-1	AVON	#A 60	OFF WHITE	—	CERAMIC TILE
W-1	CEDER	#C 363	OAK	—	RANDOM PLANK

Illustration R–1 Paint, Wall Covering, and Flooring Plan

PAINT AND WALLCOVERING NUMBER DESIGNATIONS
SHOWN ON ELEVATIONS $\frac{1}{4}" = 1'-0"$

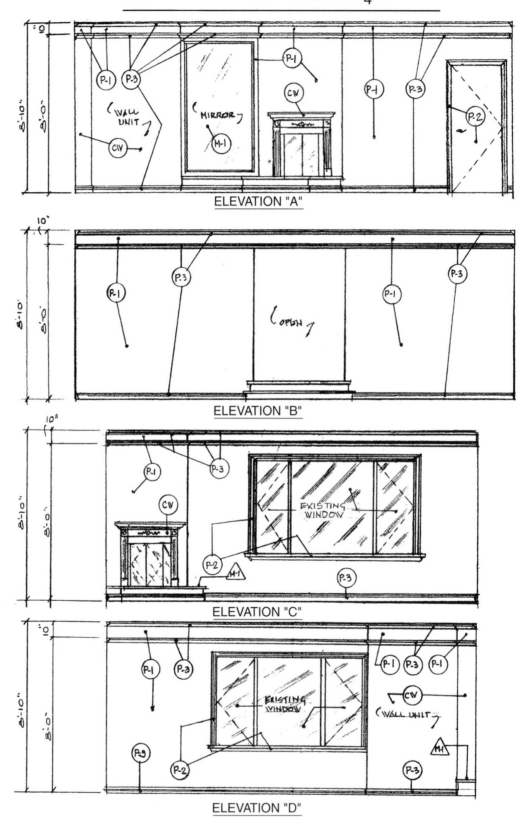

Illustration R-2 Paint and Wall Covering—Elevations

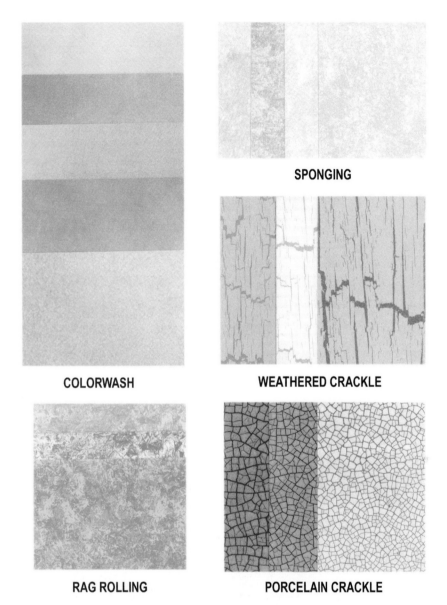

COLORWASH

SPONGING

WEATHERED CRACKLE

RAG ROLLING

PORCELAIN CRACKLE

Illustration R–3 Porcelain Crackle, Rag Rolling, Sponging, Weathered Crackle, Color Wash

Wall Treatments

There are many interesting options and methods for treating the walls; the methods you choose can create color, texture, and pattern. What you select for the walls puts all the other decorative elements into proper focus.

WALLPAPERS

BORDER & STRIPE

TOILE

BORDER & GRECIAN

Illustration R–4 Wallpaper Samples

The following wall treatment materials and methods (design tools) are available to you.

Paint

1. latex interior flat (matte flat finish for interior walls)
2. latex eggshell finish (matte finish with washability of a semi-gloss)
3. latex semi-gloss enamel (can withstand frequent washings)
4. latex pearl finish (especially suited for kitchens)
5. low luster enamel (reaches its final low luster in about 5 days).

In addition, hand-painted faux finishes, such as porcelain crackle, rag rolling, sponging, weathered crackle, and colorwash (Illustration R–3); hand-painted murals, borders, and dados (Illustrations R–4, R–5, and R–6; usually 30″–36″ from the floor); and trompe l'oeil (fooling the eye—creating a false or not real view, scene, or object; Illustration R–7) are available for you to use. These are all fashionable now and extensively used.

WALLPAPERS

Illustration R–5 Wallpaper Samples

Wallpaper

A wide spectrum of papers is available, including printed-on washable vinyls (Illustration R–8), vinylized papers, foils, and papers with matte or shiny grounds. These come in many patterns and colors in traditional, modern, eclectic, French, English, and Oriental patterns and styles (Illustrations R–4, R–5, and R–6). Beautiful mural papers, dados, and borders are especially effective in dining rooms and novelty rooms. Choosing these papers properly for foyers, dining rooms, baths (Illustration R–9), kitchens, living rooms, studies (Illustration R–10), and hallways is an important skill for you to master for creating the "background" of specific rooms.

WALLPAPERS

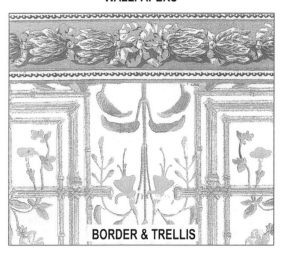

BORDER & TRELLIS

BOOK WALLPAPER

Illustration R–6 Wallpaper Samples

Fabrics

Paper-backed fabrics can be dramatic and can create texture and warmth, but these are usually a more costly method of wall treatment (it involves the cost of the fabric per yard and the cost of paper backing for application to the walls, plus labor to install). In many circumstances, however, they add an elegance and warmth that is not easily achieved by paint or paper. Fabrics also can be upholstered directly to walls, giving a soft warm look and feeling to walls.

Illustration R–7 Trompe L'oeil

Illustration R–8 Faux-Lizard Vinyl Wall Covering

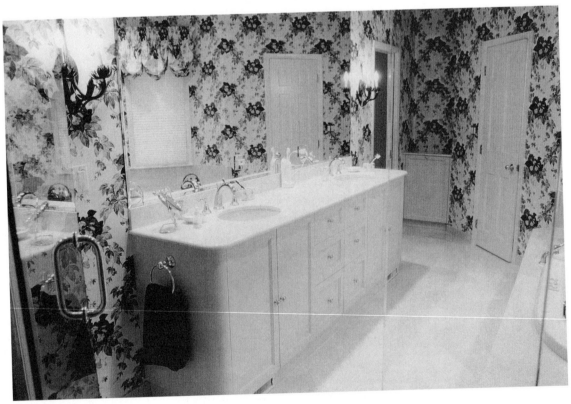

Illustration R–9 Paper in Bath

Illustration R–10 Marbleized Paper in Study

Illustration R–11 Wood Paneling

Paneling

Wood paneling, which is costly, comes in all types of woods and shades of coloring. It is used extensively in studies, dens, libraries, TV rooms, and sitting rooms (Illustration R–11). The use of paneling allows you to create contemporary, French, and English ambiances and the sense of intimacy, warmth, and luxury you expect these rooms to have.

Illustration R-12 Mirror—Dining Wall

Mirrors

If properly placed and installed, mirrors can be an extremely important tool in expanding, concealing, and creating illusions. Mirrors are available in clear, gray, solar bronze, and even black or colored (painted; Illustration R–12).

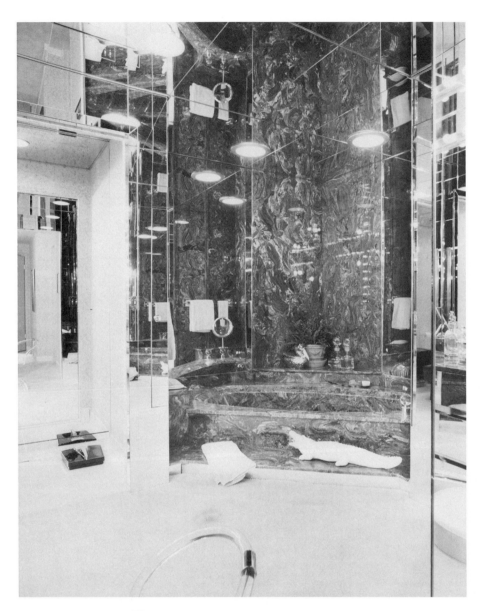

Illustration R–13 Marble on Walls

Tile, Marble, and Granite

This medium often is used for bathrooms and kitchens. There are numerous decorative, textured, and painted materials for you to choose from to create borders, dados, and walls of pattern in great rooms, dining rooms, dinettes, and foyers. Because of their hard surfaces—whether shiny or matte, patterned or plain—you can create a clean, pristine, and easily maintained environment (Illustration R–13).

Using these extensive options and choices in wall treatments, the direction and vision of your room should be crystallizing, and you should be ready to tackle the next important element of the shell.

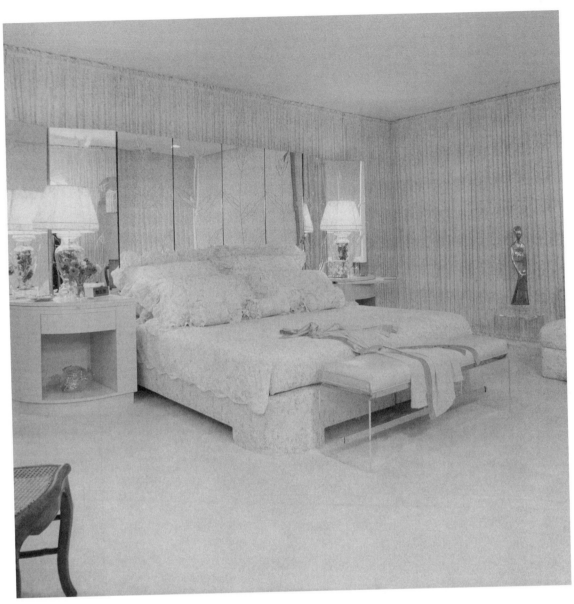

Illustration S-1 Wall-to-Wall Carpet

Floor Coverings

Floor coverings and treatments anchor the room in the same way that wall treatments create the background. They can add color, texture, pattern, warmth, and spaciousness and can set off and integrate all the other decorative elements in your room. The various options in floor covering include carpet, wood, tile, marble, and vinyl. Carpets and/or area rugs are the most frequently selected floor coverings.

Carpeting

Carpeting used to cover the floors completely (wall-to-wall; Illustration S–1) is the most commonly selected option, and it has many advantages. In a small room with a great deal of furniture, such as a bedroom (Illustration S–1), it can create the illusion of a larger space and a calmer, more serene, warmer atmosphere.

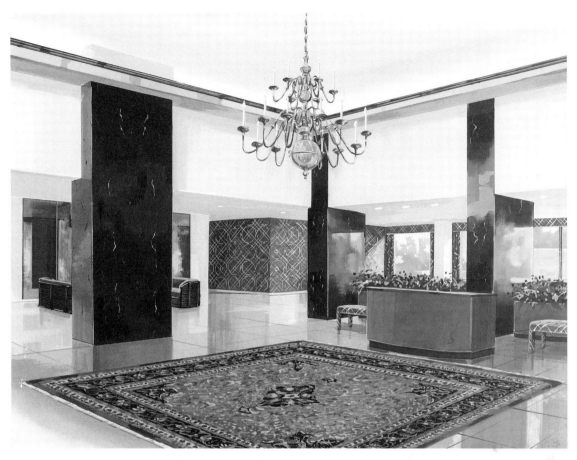

Illustration S–2 Area Rugs—Lobby

It will give that illusion in any room or hallway, but it is particularly effective in smaller rooms. In addition, it is safer underfoot than many other floor coverings.

Carpeting is woven from all types of yarns—wool, acrylics, nylons, blends, and combinations of wool and synthetics. Depending upon the yarns used, it can vary in cost tremendously, from 100 percent wools (which are the most costly) to less expensive yarns, weaves, and weights. In addition to cost, there is tremendous variance in the wearability, durability, and cleaning properties. (Nylon carpet and other synthetics are easiest to clean.) All of the aforementioned properties should be examined thoroughly and individually when selecting the type of carpet for a room.

The choices in color and pattern are virtually endless, moving from solids (the most serene) to large and small patterns and coordinating borders (see Illustration T–4). The availability of this broad spectrum of choices is found in both the less costly goods and in custom woven and designed carpets.

Area Rugs

Area rugs are another very important floor treatment. They are chosen for a different aesthetic and use than wall-to-wall carpets; they create entirely different atmospheres and ambiances and they function differently (Illustrations S–2 and S–3).

Area rugs are made from the same variety of yarns, colors, and patterns as wall-to-wall carpets, but since they usually are used to cover smaller spaces, the floor that they cover should be handsome. Area rugs can be used over bare wood, wall-to-wall carpet, marble, tile, and vinyl surfaces (Illustrations S–2 and S–3).

Illustration S–3 Area Rugs—Living Room

Since it is important that both surfaces are handsome, using area rugs often can be more costly than wall-to-wall carpet.

Area rugs also can create a hazard and require proper padding; they must be installed to minimize tripping, slipping, and falling.

Hard Surface Floors

Hard surface floors include materials such as tile, marble, ceramic, vinyl, and rubber (Illustrations S–4, S–5, and S–6). These flooring surfaces can be broken down into four divisions:

1. Real wood floors and synthetic mica floors are installed in strips on the diagonal, in herringbone patterns, in parquet patterns (Illustration S–5), or with pattern insets. They usually have a polyeurene finish, are used extensively, and come in all qualities, grades, and types of wood (oak, maple, pine, etc.) and colorations. They are extremely popular and handsome and are often used under area rugs. The synthetic mica floors are very similar visually, but they are installed more quickly over a foam cushion and have very low maintenance.

2. Tile and ceramic floors come in so many shapes (such as Mexican Clay in Illustration S–6), types, colors, and textures that it is difficult to name all those available. They are used extensively in bathrooms and kitchens and are popular because of their easy maintenance and the tremendous variety of choices available as well as their reasonable cost (see Illustration T–5).

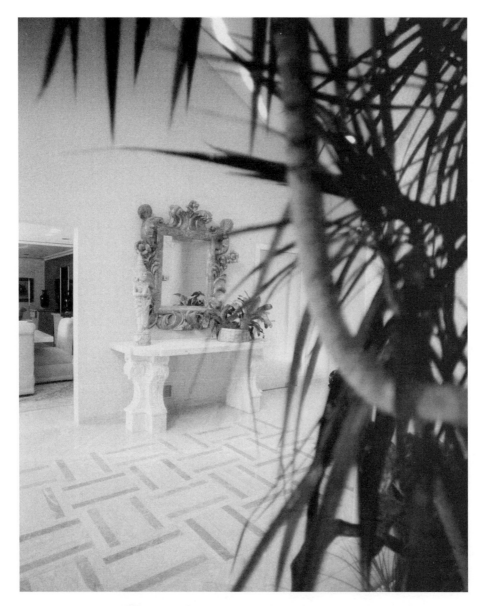

Illustration S–4 Marble Pattern Floor

3. Marble and granite are usually more costly than ceramic tile, but these materials also offer many choices in quality, colors, and patterns. They are handsome and elegant surfaces and are important in setting the "tone" of the room or rooms you are designing (Illustration S–4).

4. Vinyl, including sheet vinyl (linoleum), high-quality vinyl squares (which are more costly), and high-grade sheet vinyl (Illustration S–7) such as Lonseal, are used extensively in kitchens and family rooms. These surfaces and rubber flooring such as Perlotta are used for very high-traffic commercial areas (such as airports) and residential areas (such as on stairs). These come in many patterns and colors. They are very sturdy, soft underfoot, and easily maintained. Vinyl has an important advantage over other flooring surfaces: in the event of a fall from slippage, it forms a much more cushioned surface than tile, granite, or wood.

Keep in mind that each of the previously listed flooring types creates a completely different ambiance for your work. Flooring should be selected and installed for the appearance it creates, its cost, its maintenance properties, and most importantly, its suitability for the physical area it is covering.

Illustration S–5 Wood Parquet Floor

Illustration S–6 Mexican Clay Ceramic Floor

Illustration S–7 Black High-Gloss Sheet Vinyl Floor

Window Treatments

Window treatments are the final element in the structure of the room's shell. The architecture of the windows in your room is very important to the impact these windows will have on the entire room's decoration. Windows have been called the "eyes of a room" and, as such, can be left bare or untreated, depending upon the view and its architecture. They also can be treated to make them appear more beautiful, more dramatic, more casual, more subtle, or more concealed. In conjunction with wall and floor treatments, window treatments complete the stage setting for the integration of all the other decorative elements in your room and for your vision of the room.

The most familiar types of window treatments and designs are described in the following pages, including valances, sheers, draperies, blinds, and shades. Each installation should be selected in accordance with the entire decoration plan for your particular room; bear in mind the architecture of the windows, what room you are designing, and whether or not privacy is needed.

In discussing any window dressing, hardware (poles, finials, rods and wands, and rings and tie-backs) always must be considered. This hardware is a multifaceted category and its use is most valuable in making a strong statement for your design concept.

Since there are so many types of window installations, we have prepared a number of drawings for you to study (see Illustrations T–1 and T–2). Each one is a different version of a familiar category of treatment with different top treatments (see numbers 3, 4, and 5 and numbers 2, 6, and 7 in Illustration T–1). These should indicate to you the various ways your creativity can treat and solve a similar design problem. In numbers 1 and 6 in Illustration T–2, we have shown two different treatments for screens or shutters. Element number 1 is a Shoji screen installation; it is very popular in many avant-garde rooms, such as lofts. At the other end the spectrum is number 6. These wood shutters are used extensively in more traditional homes. Elements 3, 4, and 5 show three different but similar treatments—a balloon shade, a Roman shade, and an Austrian curtain. All of these are very effective, but they create different ambiances: number 3 creates a fussy ambiance, number 4 lends a more tailored feeling, and number 5 has a definite country ambiance. The draw curtain in number 2 is a simple solution compared to 7, a swag with rosettes and jabots and a draw curtain undercurtain. Element 7 is a softer, more creative and elegant treatment for a similar window. The photos in Illustrations T–3, T–4, and T–5 offer additional window designs to consider.

For a double-height window with a lovely view, a very sheer swag installation (Illustration T–3) and side hanging sheers was selected. Using this treatment makes the window decorative without obscuring the view. Another example of a similar installation—swag valances installed as a decorative element over a large expanse of floor to ceiling windows overlooking a waterway—is shown in Illustration G–4.

Another popular and familiar installation, balloon shades and/or balloon shade valances (Illustrations T–4 and O–1), are very decorative and provide ample privacy if desired. In the room shown in Illustration T–4, they create the perfect setting for the window seat and pillows. The fabric selected for the shades is the same print as the comforter-spread on the bed, completing a Country French coordinating decoration scheme in a large master bedroom with a high ceiling.

Illustration T–5 shows theatrical use of fabric and design in combination with the window treatment. It illustrates a lovely draped wall in the same fabric as the window treatment installed in a room with shades of white, setting the stage for the simplicity of the furnishings and creating a warm, inviting ambiance.

Illustration T–6 shows one of the numerous blind installations available. This treatment is in a large, luxurious bathroom. Venetian blinds in silver metal give the room a clean, architectural ambiance that blends into the mirrored wall and increases the total illusion of space. It affords privacy while allowing a certain amount of light to penetrate into the room.

By mastering the three vital decorative elements of the "shell" (floor, wall, and window treatments), you will establish and define your mental vision of what and how you wish the room to appear. With proper care and attention to these elements and intelligent and aesthetic selections, your room will take on the ambiance necessary to create a wonderful environment for yourself no matter what the function of the room may be.

WINDOW TREATMENTS
LINE DRAWINGS-INSTALLATIONS

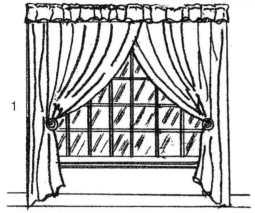

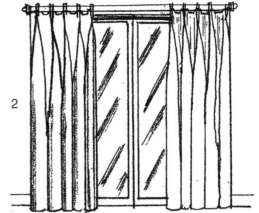

1 — DOUBLE TIE-BACK SHURRED BALANCE

2 — STRAIGHT HANGING DRAPES ON A POLE AND RINGS DOUBLE OPENING

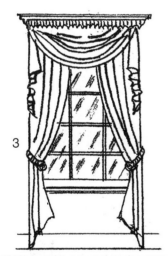

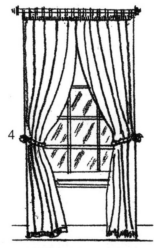

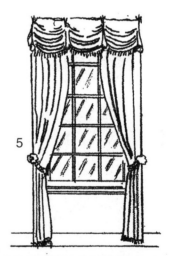

3 — SWAG, WOOD CROWN AND TIE -BACKS WITH JABOTS

4 — TIE-BACKS ON WOOD POLE

5 — SHORT BALLOON VALANCE W/FRINGE AND TIE-BACKS

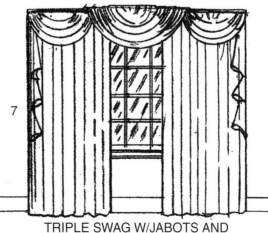

6 — SHAPED VALANCE AND STRAIGHT HANGING DRAPES

7 — TRIPLE SWAG W/JABOTS AND STRAIGHT SHEERS UNDER

WINDOW TREATMENTS
LINE DRAWINGS-INSTALLATIONS

1 SLIDING SHOJI SCREENS

2 ONE WAY DRAW DRAPE

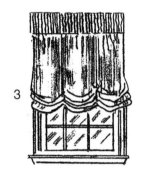

3 BALLOON SHADE

4 ROMAN SHADE

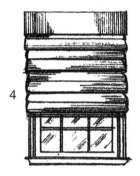

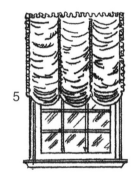

5 AUSTRIAN SHADE

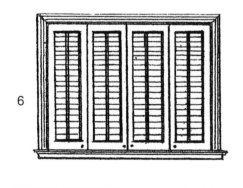

6 WOOD SHUTTERS

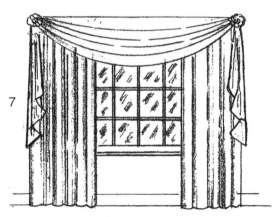

7 SWAG W/JABOTS, ROSETTES AND
DRAWER CURTAINS

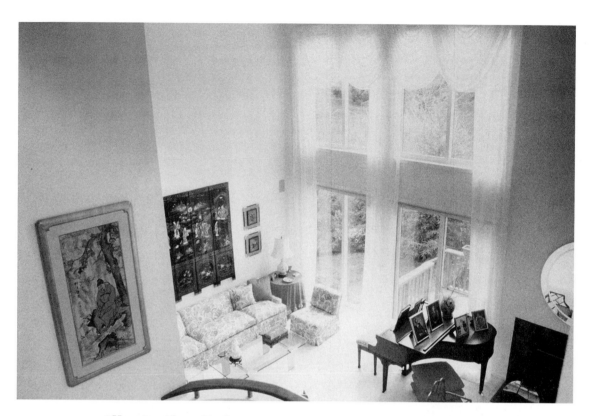

Illustration T–3 Sheer Installations—Double-Height Ceiling

Illustration T–4 Balloon Shade Valance

Illustration T–5 Theatrical Wall Curtain

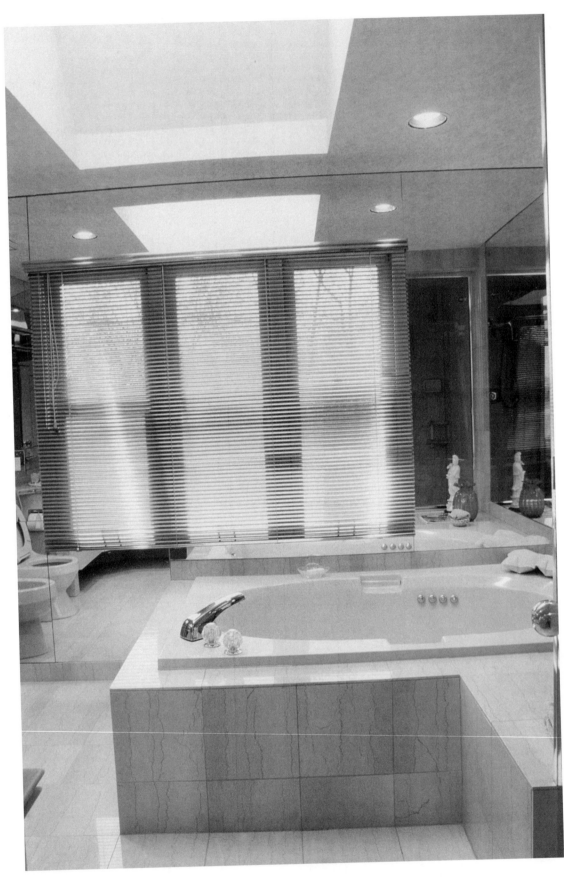

Illustration T–6 Venetian Blind–In Bath

LIGHTING

Creating appropriate lighting for a room is both an exacting science and an art. Like an artist, you will want lighting to create certain highlights and drama in a room you are designing. Lighting can create a bright, sunny atmosphere; a soft, romantic one; an eerie, disturbing ambiance; a subdued, serene one; or a somber, moody ambiance. An entire range of emotional responses can be created by lighting. It is a theatrical tool that can and should be used for the total success of any room.

You also must consider the technical aspects of lighting for a project, however. In considering these aspects, you must remember to let your floor plan guide your lighting plan. The lighting in your room must directly relate to the floor plan, creating appropriate general lighting, task lighting, and overall atmosphere. There are specific symbols in drawing your lighting plan as there were specific symbols for the floor plan. We have depicted these in Illustration U–1 to assist you. We have used (and you should use) a transparent or thin onion skin over a furniture plan to record these symbols; that way, when designing your lighting plans, you can see the relationship between the lighting layout and the furniture and make sure you are not blocking the switches with furniture. This is called a reflected lighting plan, as if the floor was a mirror reflecting what is happening on the ceiling (Illustrations U–2 and U–3).

This plan must be professionally drawn with care and knowledge so that the electrical contractor easily can read and execute the plan. With experience, as well as the symbols we have outlined and the examples we have provided, this process will become easier over time. In Illustration U–2 we have provided a lighting plan for the floor plan in Illustration H–1; in Illustration U–3 we depict the lighting plan for the floor plan in Illustration J–1. These illustrations will guide you in this learning process. For consistency we have used the floor plans from the earlier Illustrations H–1 and J–1 so that you may see the complete development of a project.

Study these lighting plans carefully, noting the importance of the lighting positions and the types of lighting fixtures we are suggesting as well as the switching we have specified for all this lighting, including one-way and three-way switching. The switching installations are of tremendous importance because they function to provide proper illumination in entering and exiting locations. Also take note of the use of dimmers, which are employed to create varying atmospheric or theatrical effects.

There are many forms of fixtures for overhead lighting. Among those familiar to all of us are chandeliers (Illustration U–4; reproductions and antiques), track fixtures (Illustration U–5; which have great flexibility to form patterns and move in many directions), recessed high hats (see Illustration R–12; the most flexible in installation, providing the ceilings have adequate room to house the recessed cans), and suspended and shaped ceiling soffits that house and conceal lighting fixtures (see Illustration S–5). There also are many types of wall fixtures available: sconces (Illustration U–6), swing-out wall lamps (Illustration U–7), and decorative fixtures for illuminating areas, as well as table lamps and standing lamps (see Illustration S–1). In naming these we have only touched upon a few types that are usually employed, but these fixtures are readily available on the market and solve many of your lighting problems with great ease and success.

The actual bulbs for lights can vary, depending upon the illumination level desired. Fluorescent bulbs are used for task lighting or general illumination. Halogen bulbs, a more blue-white intense illumination, can be used for the same purposes but they are more costly than fluorescent lighting.

This very short overview will give you insight into the broad spectrum of lighting products available in the marketplace and should help arouse your curiosity about the vast amount of lighting fixtures available. Furthermore, new products are constantly invented and manufactured, giving you the ability to be highly creative and effective in your selection of products to execute your lighting designs for the projects you are decorating.

Lighting Legend

⊕ — Recessed Incandescent Downlight 150W R40 Flood Lamp

⊕▶ — Recessed Incandescent Wallwasher 150W R40 Flood Lamp

⊕ — Provide Junction Box on Ceiling for Chandelier

⊢Ⓢ — Provide Wall Junction Box for Sconce ¢ 6'0" Aff

⊕ — Provide Wall Junction Box for Swing Arm Lamp ¢ 41" Aff

Ⓢⓜ — Surface Mounted Fixture (Symbol Not Shown on Plans)

 Used When Fixture Cannot be Recessed in Ceiling

△ — Track Light Fixture (Symbol Not Shown on Plans) Used When

 Fixture Cannot be Recessed in Ceiling or for Accent Lighting

⊢Ⓣ — Thermostat

$ — Wall Mounted Switch (Tap or Toggle)

$³ — Wall Mounted 3-Way Switch (Tap or Toggle) Means Switch Can

 Be Turned On & Off From 2 Locations

⊢D — Wall Mounted Dimmer Switch (Dimmer Size Determined on

 Wattage of Fixtures on Dimmer) (Slide Dimmer)

⊢D³ — Wall Mounted 3-Way Dimmer - Means Dimmer Can Be Turned

 On & Off From 2 Locations But Only Dimmed from the

 One With the Symbol ⊢D³

a — Lower Case Letter Denotes Circuiting

Note: As you acquire more knowledge of lighting and its accessories, you will create new

 symbols as required to suit your needs to produce a reflected ceiling plan.

Illustration U−1 Lighting Legend

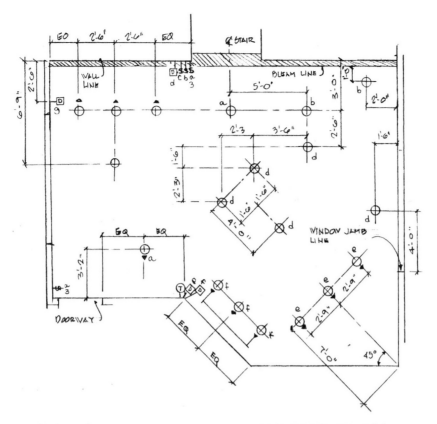

ILLUSTRATION U-2a LIGHTING PLAN

Illustration U–2a Lighting Plan—For Illustration H–1

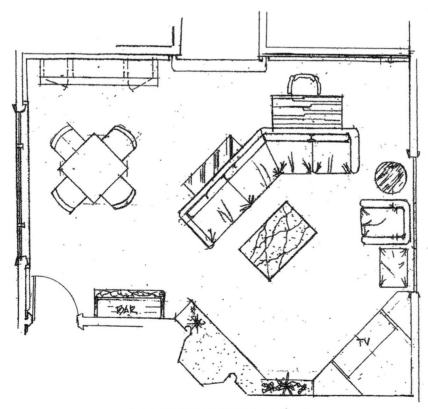

ILLUSTRATION U-2b

Illustrations U–2b Floor Plan—For Illustration H–1

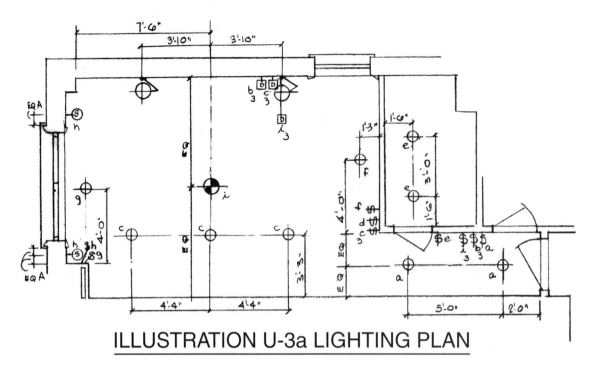

ILLUSTRATION U-3a LIGHTING PLAN

Illustration U–3a Lighting Plan—For Illustration J–1

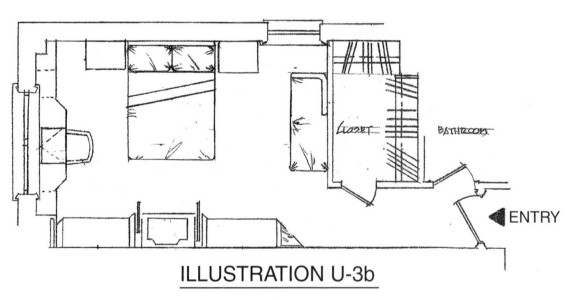

ENTRY

ILLUSTRATION U-3b

Illustration U–3b Floor Plan—For Illustration J–1

Illustration U–4 Chandeliers

Illustration U–5 Track Fixtures

Illustration U–6 Sconces–In Dining Area

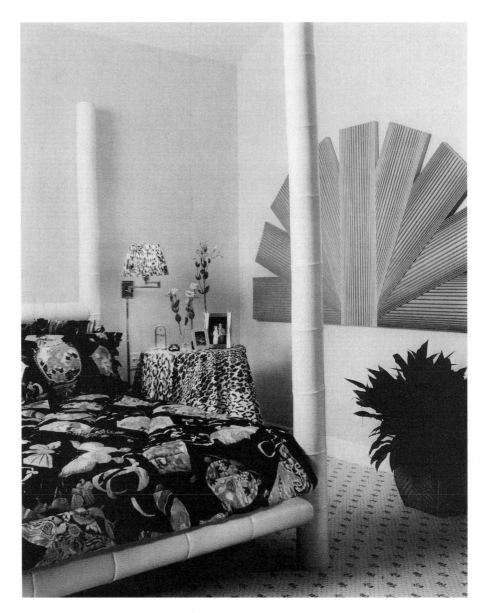

Illustration U–7 Swing-Arm Lamps

ARCHITECTURAL ELEMENTS

Architectural elements—such as columns, moldings, built-in units, fireplaces, mirrors, arches, and beams—become the architectural structure of the room. They may or may not be necessary to include in your decorating scheme, depending on how complex or simple you wish to keep your room. Photographs of various architectural elements will illustrate how these elements can be used successfully and effectively.

Illustration V–1 Mirror—Small Room—Two Walls

Mirrors

Illustration V–1 shows a small room that had no windows. Mirrors were installed on two walls to expand and create a wonderful space with a tented ceiling.

In a condominium lobby (Illustration V–2) a mirror was used on columns to conceal their structural necessity and expand the space so people would not be conscious that these columns were in the wrong place aesthetically.

In a relatively small master bedroom (Illustration V–3), the wall behind the bed was completely mirrored to expand the room upon entering it and to reflect the wonderful built-in cabinetry opposite the mirror.

Illustration V–2 Mirror—Lobby with Columns

Illustration V–3 Mirror—Bedroom

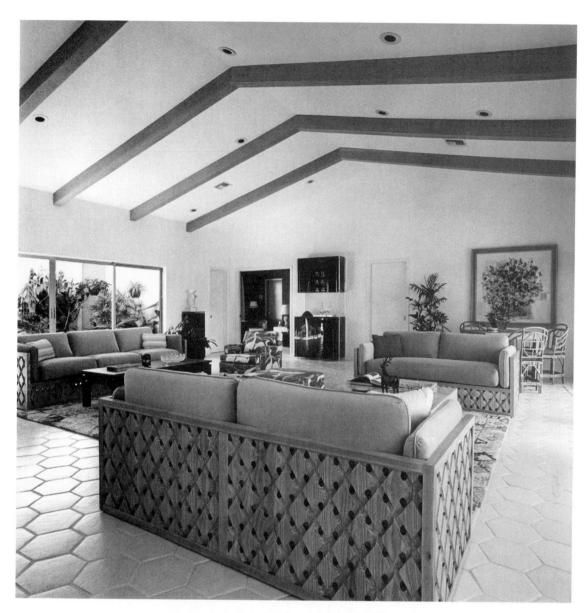

Illustration V–4 Beams—Living Room

Beams

Illustration V–4 shows beams installed on a high-pitched ceiling used to accentuate the shape of the ceiling and height of the room. The design and installation of the beams gave the ceiling and the room the architectural interest that it was lacking before this installation.

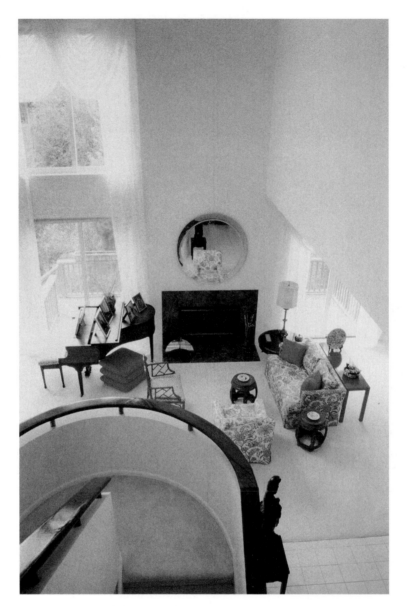

Illustration V–5 Fireplace

Fireplaces

In a traditional living room, a fireplace became the focal point for the seating as well as the handsome painting above the fireplace (see Illustration G–1).

In the traditional French Country home in Illustration O–1, the fireplace again became the focal point for the seating arrangement as well as a wonderful foil for an amusing sculpture.

In the eclectic, unusually high-ceiling room shown in Illustration V–5, a fireplace became the strong focal point dividing two areas—dining and living. The fireplace was emphasized by a contemporary round mirror above the mantle.

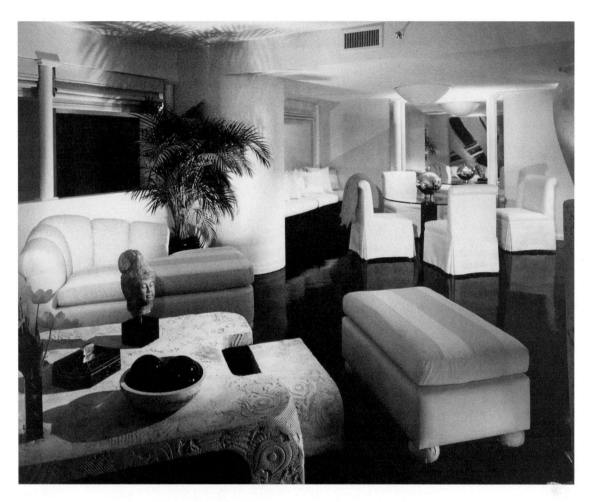

Illustration V–6 Columns—Showhouse Room

Columns

In the striking contemporary Trump showhouse room shown in Illustration V–6, columns were installed to define and set off the floor-to-ceiling mirror installed at the end of the room.

Illustration V–7 Ceiling Soffit

Ceiling Soffits

In the Palm Beach apartment shown in Illustration V–7, a shaped ceiling soffit was installed and built over the round dining area. High hat lights were installed inside the soffit to illuminate the table and general area. It was completely stuccoed (as were the walls and ceiling) to render a French or Italian Riviera ambiance.

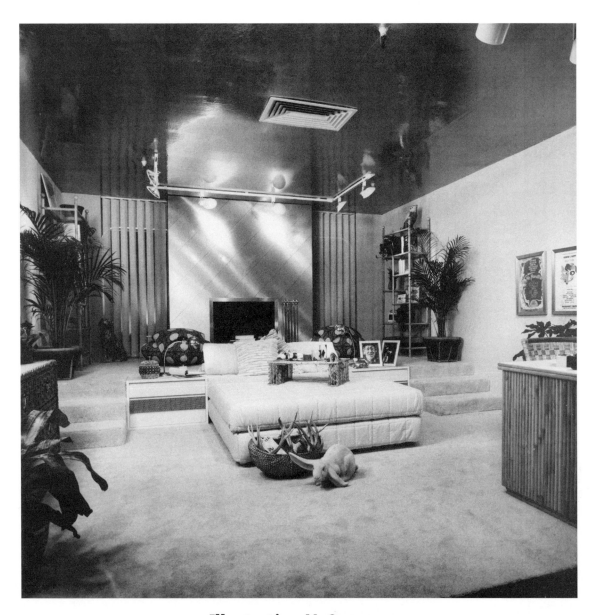

Illustration V–8 Platform

Platforms

A platform was installed in the bedroom/sitting room shown in Illustration V–8 to define the area in front of the fireplace and to serve as a headboard for the bed. The platform created two separate areas in one physical space.

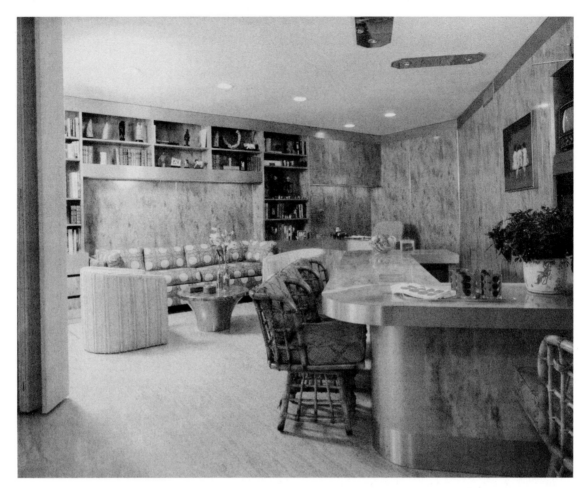

Illustration V–9 Built-Ins

Built-ins

In the large room shown in Illustration V–9, which is directly adjacent to the living area, a number of requirements (a bar eating area, a desk for working at home, additional sleeping, and a library) were incorporated very successfully by built-ins in the entire space.

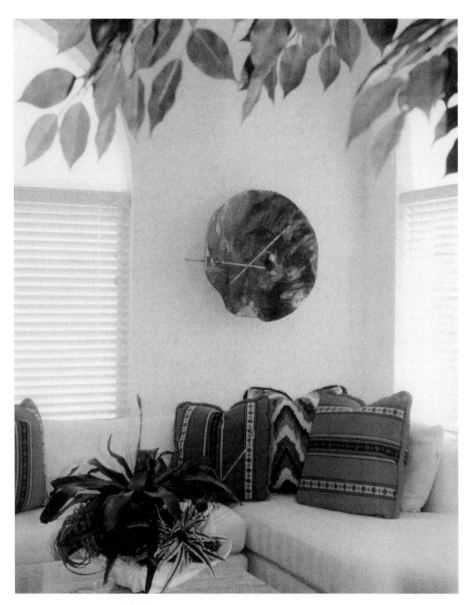

Illustration W–1 Pillows and Wall Sculpture

ACCESSORIES

Of all the elements involved in the decoration of your room, accessories play a unique role. They are considered the jewelry of a room; they personalize it and make it come alive in many ways. The right accessory brings life to your sofa (pillows; Illustration W–1), coffee table (ornaments, China plates, boxes, books, and sculpture; Illustration W–2), and, of course, walls (mirrors; Illustration W–3; paintings; Illustration W–4).

There is an extensive range of choices in accessories, but it is important to first determine the degree of interest you have in object d'art, including paintings, lithographs, sculpture, family photos, china, silver, glassware, ceramics, antiques, and contemporary pieces.

Questions you should ask yourself (or perhaps your clients) include: Do you have any specific collections or are you interested in becoming a future collector? Do you have any particular hobbies you might want to feature in your home (i.e., backgammon and chess sets or beautiful glass animals and objects)? Are you interested in original contemporary paintings or lithographs or sculpture?

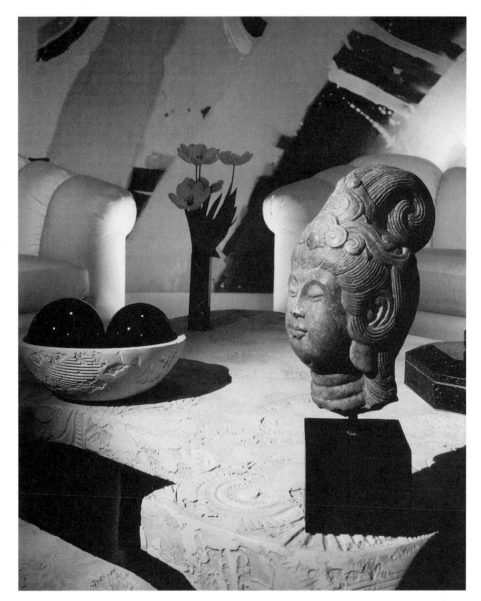

Illustration W–2 Sculpture

The answers to such questions will guide you as to where to start in your quest for handsome and exciting accessories. Again, there are no set rules on how to dress a room, but the selection of proper sources, antique shops, shops devoted primarily to accessories, and art galleries is invaluable to you in your search.

For this element to be truly successful and handsomely integrated into your decorating plan, a discriminating eye is invaluable. Your eye constantly should be aware of your environment. The more you absorb and notice, the more you will be able to select, choose, suggest, and edit. As a result, your room will be more successful. It is crucial to have a vision of your completed project; the accessories we have outlined in this section can supply that finishing touch.

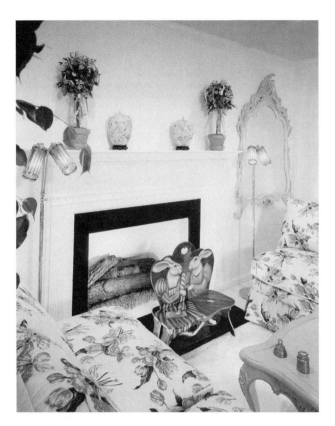

Illustration W–3 Framed Mirrors and Accessories

Illustration W–4 Painting

ASCERTAINING BUDGETS

Now that we have discussed all the decorating elements to integrate into your decorating plan, this final section offers a way to ascertain what you or your clients would or would not spend for a project. More often than not, you will not have a definitive idea of what a project will truly cost, but you will have a general idea of what you can or cannot spend in total. As a result, it is impossible to determine what the budget will be relative to what a home costs. In addition, asking about income is not politically correct. Therefore, the best and most tactful method for developing a project budget is to use the following questionnaire.

		Check one
1.	What would you spend for furnishings for the living room?	____ $10,000–15,000
		____ $20,000–30,000
2.	What would you spend for furnishings for the family room/great room?	____ $10,000–15,000
		____ $20,000–30,000
3.	What would you spend for furnishings for the den/study?	____ $ 5,000–10,000
		____ $15,000–20,000
4.	What would you spend for furnishings for the dining room?	____ $ 7,500–10,000
		____ $10,000–15,000
		____ $20,000
5.	What would you spend for furnishings for the home office?	____ $ 5,000–7,500
		____ $ 7,500–10,000
6.	What would you spend for furnishings for the master bedroom?	____ $ 7,500–10,000
		____ $10,000–15,000
		____ $15,000–20,000
7.	What would you spend for furnishings for the children's room/ guest room?	____ $ 1,500–2,500
		____ $ 2,500–7,500
		____ $ 7,500–10,000

CONCLUSION

Becoming an interior designer is both a learned process and an art. It has been our intention in this book to simplify the process of interior design by outlining it in a realistic, definitive manner. We believe that designing in this logical, systematic way will make the learning process easier for you and it will make interior design more meaningful.

We have broken this learning process into a specific, itemized, and logical method to enable you to understand, realize, and recognize the complexities involved in interior design. As a result, when you have mastered all we have presented, including the following activity pages, you will be ready to embark on the final step—**experience**. With the strong foundation this book provides, you should be well prepared to step into the real world of interior design and be able to understand the marketplace, thereby gaining real-world experience.

Whether you would like to work in a design firm, with a retail establishment, or simply to design and decorate your own home, the information you have learned in this book, along with experience, continuous development as an artist, and dedication, should allow you to enjoy great success and personal pleasure as an interior designer.

WORKSHEETS

Worksheet 1—Dining Room

The following worksheet includes:

> Worksheet 1 An answered questionnaire (we have included the specific items that we would like you to use when creating the floor plan).
>
> Worksheet 1–A The existing **shape** of the dining room.
>
> Worksheet 1–B The existing shape of the dining room with dimensions.

> **Project**: Convert these measurements into a 1/4″ scale drawing.
>
> **Project**: Create a floor plan from your drawing to scale using the answers we have provided for you in the questionnaire.

Worksheet Figure 1–C in Appendix A presents a suggested answer for this project.

Dining Room/Breakfast Room Questionnaire
Worksheet 1

Items

1. Is this area a dining room or breakfast area? ✔ Dining area
 ____ Breakfast area

2. Is it necessary for your dining table to open? ✔ Yes ____ No

3. If not, how many people do you want to seat? ____ 4–6 ____ 6–8 ____ 8–10

4. If so, how many people do you want to seat? ____ 6–8 ✔ 8–10

5. Do you want your dining room to have an area for

 ____ Storage ____ Display

 ____ Serving ✔ All 3

6. Would you like your dining chairs to include ✔ Host chairs

 ✔ Hostess chairs

 6 Side chairs

 ____ Arm chairs

7. What table shape do you want? ✔ Round

 ____ Oval

 ____ Rectangle

 ____ Square

 ____ Banquette

8. Table size—check size desired

	4–6	6–8	✔ 8–10
Round	42″ or 48″φ	48″ or 54″φ	✔ 54″ or 60″φ
Rectangular	30″ × 60″	36″ × 72″	48″ × 84″
Square	48″	54″	60″
Oval	30″ × 60″	36″ × 72″	48″ × 84″

(In cases where extension leaves are used, their sizes are determined by the length of the room, leaving enough room for passage between walls, buffets, display units, and chairs.)

9. The floor plan should include two decorative screens and a 20″ × 72″ buffet.

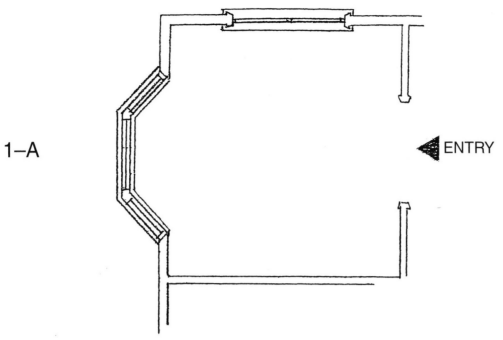

1–A

ENTRY

PLAN OF A PROPOSED DINING ROOM
NOT TO SCALE

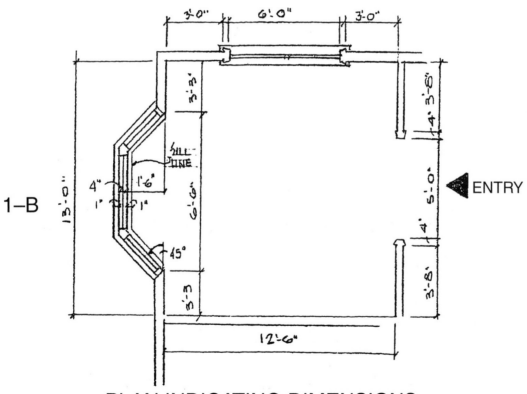

1–B

ENTRY

PLAN INDICATING DIMENSIONS
TO PRODUCE $\frac{1}{4}^{"}$ = 1'-0" DRAWING
NOT TO SCALE

Worksheets 1–A and 1–B Dining Room—Worksheet Illustration

Worksheet 2—Children's Room

The following worksheet includes:

Worksheet 2 An answered questionnaire (we have included specific items for you to use in your floor plan).

Worksheet 2–A The existing **shape** of the children's room.

Worksheet 2–B The existing shape of the children's room with dimensions.

Project: Convert these measurements into a 1/4″ scale drawing.

Project: Create a floor plan from your drawing to scale using the answers we have provided for you in the questionnaire.

Worksheet Figure 2–C in Appendix A is a suggested answer to this project.

Children's Room/Teenager's Room/Boy's-Girl's Nursery Questionnaire
Worksheet 2

Items

1. What ages and sex are the children?
 - ✔ Pre-teens
 - ___ Teens
 - ___ Infants
 - ✔ Boys
 - ✔ Girls

2. Would you like to include
 - ✔ Desk and desk chair
 - ✔ Bookshelves
 - ✔ Storage area
 - ✔ TV
 - ✔ Stereo
 - ✔ Computer
 - ✔ Dresser
 - ✔ Seating

3. Would you like a Murphy Bed in this room? ___ Yes ✔ No

4. What size bed would you like?
 - ___ Crib
 - ___ Queen—60″
 - ___ Double—54″
 - _2_ Single—36″–39″
 - ___ High-riser
 - ___ Bunk beds

5. The floor plan should include: two 36″ × 75″ beds, 39″ plastic corner unit, built-in dresser, desk, file and drawer unit, wall book and storage unit, desk chair, arm chair, 36″ × 20″ chest, and swing-arm lamps.

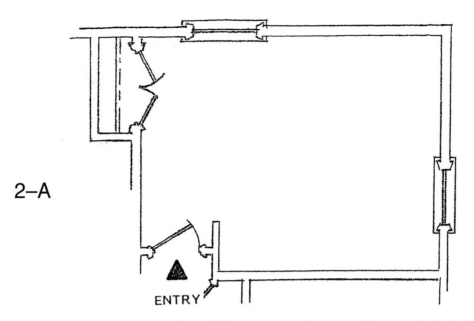

2–A

PLAN OF A PROPOSED CHILDREN'S ROOM
NOT TO SCALE

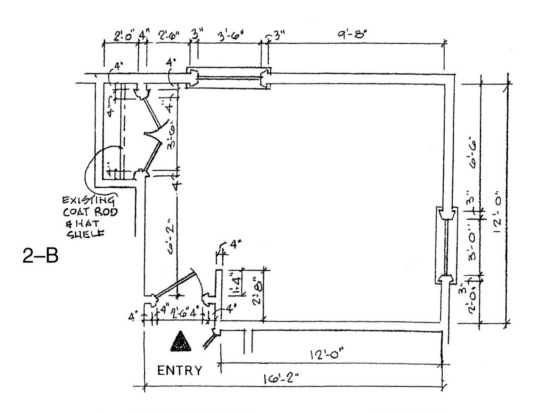

2–B

EXISTING COAT ROD & HAT SHELF

ENTRY

PLAN INDICATING DIMENSIONS
TO PRODUCE $\frac{1}{4}" = 1'\text{-}0"$ DRAWING

Worksheets 2–A and 2–B Children's Room—Worksheet Illustration

Worksheet 3—Master Bedroom

The following worksheet includes:

Worksheet 3 An answered questionnaire (with specific items for you to include in floor plan).

Worksheet 3–A The existing **shape** of the master bedroom.

Worksheet 3–B The existing shape of the master bedroom with dimensions.

Project: Convert these measurements into a 1/4″ scale drawing.

Project: Create a floor plan from your drawing to scale using the answers we have provided for you in the questionnaire.

Worksheet Figure 3–C in Appendix A is a suggested answer for this project.

Master Bedroom/Guest Bedroom/Sitting Room Questionnaire
Worksheet 3

Items

1. Which room are we working on? ✔ Master bedroom
 ___ Guest bedroom
 ___ Sitting room

2. What size bed do you want for this room? ___ King 78″
 ✔ Queen 60″
 ___ Single 36″–39″
 ___ Double 48″–54″

3. Do you like poster beds? ___ Yes ✔ No

4. Do you want a TV in your bedroom? ✔ Yes ___ No

5. Do you want book storage? ___ Yes ✔ No

6. Would you like some seating in your bedroom? ✔ Yes ___ No

7. Do you like armoires? ✔ Yes ___ No

8. Would you like a desk in your bedroom? ✔ Yes ___ No

9. Do you have any built-ins existing in your room now? ___ Yes ✔ No

10. Do you need a dresser? ✔ Yes ___ No

11. Do you need a man's highboy? ___ Yes ✔ No

12. The floor plan should include: a 32″ lounge chair, 32″ × 20″ ottoman, 16″ φ lamp table, 20″ × 48″ chest, 24″ × 60″ armoire, two arm chairs, 60″ × 80″ queen bed, 18″ × 54″ bench, 24″ × 48″ desk with desk chair, 20″ × 60″ dresser with mirror above, and 24″ octagon night table.

3–A

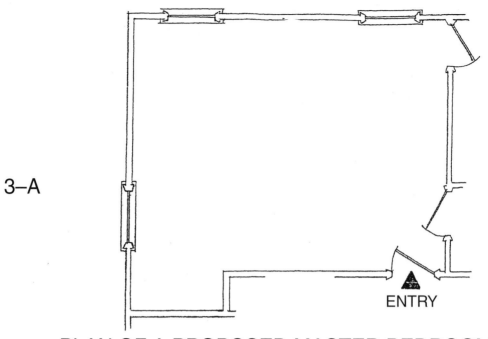

PLAN OF A PROPOSED MASTER BEDROOM
NOT TO SCALE

3–B

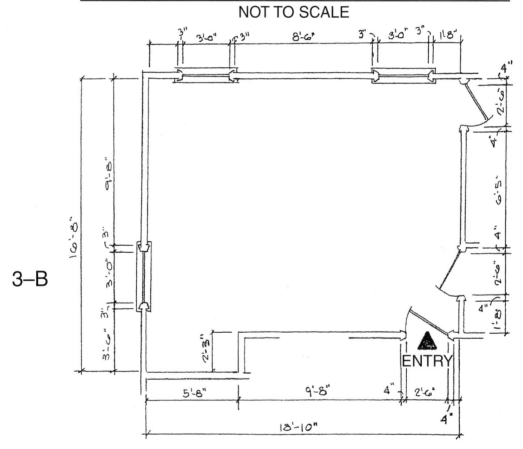

PLAN INDICATING DIMENSIONS
TO PRODUCE $\frac{1}{4}$" = 1'-0" DRAWING

Worksheets 3–A and 3–B Master Bedroom—Worksheet Illustration

Worksheet 4—Family Room/Library

The following worksheet includes:

Worksheet 4 An answered questionnaire with specific items to be included in floor plan.

Worksheet 4–A The existing **shape** of the family room.

Worksheet 4–B The existing shape of the family room with dimensions.

Project: Convert these measurements into a 1/4″ scale drawing.

Project: Create a floor plan from your drawing to scale using the answers we have provided for you in the questionnaire.

Worksheet Figure 4–C in Appendix A presents a suggested solution for this project.

Living Room/Family Room/Great Room/ Den/Study/Library Questionnaire

Worksheet 4

Items

1. Which room are we working on?

 A ____ Living room
 B ✔ Family room
 C ____ Great room
 D ____ Den
 E ____ Study
 F ✔ Library

2. Do you want to use this room for TV-HiFi-VCR? ✔ Yes ____ No

 Home entertainment? ✔ Yes ____ No

 If so, do you want an entertainment center? ✔ Yes ____ No

3. Do you want to provide for a bar in this room? ____ Yes ____ No

4. Do you want the bar to be a ____ Wet ____ Standing ____ Sitdown

5. Do you want to provide room for books? ✔ Yes ____ No

6. Do you need a sleeper sofa in this room? ____ Yes ✔ No

7. Is a recliner important in your room? (2) ✔ Yes ____ No

8. Do you play cards or games? If so, do you want a card table in this room? ____ Yes ✔ No

9. Do you need a desk? ____ Yes ✔ No

10. Should seating accommodate 6–8 people? ✔ Yes ____ No

 8–10 people? ____ Yes ____ No

 10–12 people? ____ Yes ____ No

11. Do you have any built-ins existing in your room? ____ Yes ✔ No

12. Do you want to provide for display? ✔ Yes ____ No

13. The floor plan should include: display, storage, bookcases, 24″ × 60″ piano, three 24″φ coffee tables, two 34″ recliners with 18″ extensions, four triangle-shaped tables, two 34″ × 72″ sofas, and built-ins.

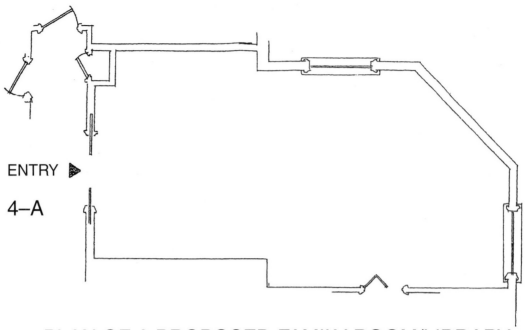

ENTRY ▶

4–A

PLAN OF A PROPOSED FAMILY ROOM/LIBRARY
NOT TO SCALE

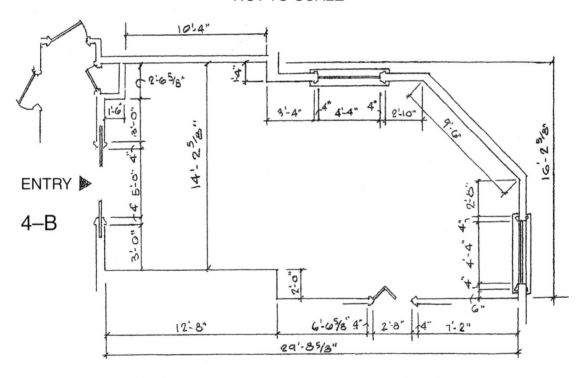

ENTRY ▶

4–B

PLAN INDICATING DIMENSIONS
TO PRODUCE $\frac{1"}{4}$ = 1'-0" DRAWING
NOT TO SCALE

Worksheets 4–A and 4–B Family Room/Library—Worksheet Illustration

Worksheet 5—Office

The following worksheet includes:

Worksheet 5 An answered questionnaire (we also have included specific items to be used in the floor plan).

Worksheet 5–A The existing **shape** of the office.

Worksheet 5–B The existing shape of the office with dimensions.

Project: Convert these measurements into a 1/4″ scale drawing.

Project: Create a floor plan from your drawing to scale using the answers we have provided for you in the questionnaire.

Worksheet Figure 5–C in Appendix A offers a suggested solution for this project.

Home Office Questionnaire

Worksheet 5

Items

1. Is this room to be used as a ___ Full-time office

✔ Part-time office

2. Do you need an area for built-ins ✔ TV

Desk/cabinetry for built-in ✔ Telephone

✔ Computer/printer

✔ Storage

✔ Bookshelves

✔ Fax machine

✔ File storage

3. Would you like seating in this room to be ✔ Sleeper sofa

___ Regular sofa

4. Would you like a recliner? ___ Yes ✔ No

5. Would you like a pull-up chair for the desk? ✔ Yes ___ No

6. The floor plan should include: two side arm chairs, 36″ × 18″ coffee table, two swing arm lamps, 30″ × 84″ desk with 20″ × 42″ left-hand return, built-ins, and side units on either side of the sofa.

Worksheet 6—Living Room

The following worksheet includes:

Worksheet 6 An answered questionnaire with specific items to be included in the floor plan.

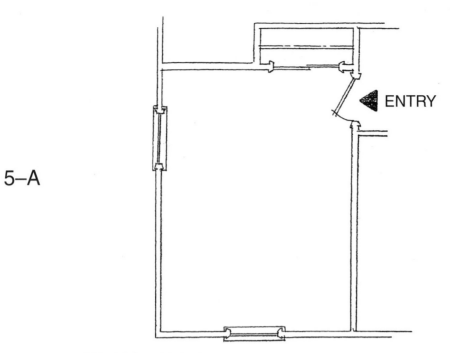

PLAN OF A PROPOSED HOME/OFFICE

NOT TO SCALE

5–A

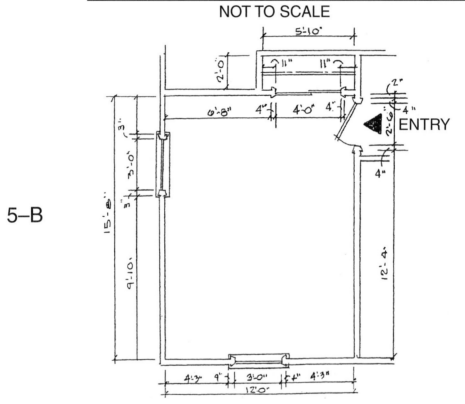

PLAN INDICATING DIMENSIONS
TO PRODUCE $\frac{1}{4}$" = 1'-0" DRAWING

NOT TO SCALE

5–B

Worksheets 5–A and 5–B Office—Worksheet Illustration

Worksheet 6—Living Room

The following worksheet includes:

Worksheet 6 An answered questionnaire with specific items to be included in the floor plan.

Worksheet 6–A The existing **shape** of the living room.

Worksheet 6–B The existing shape of the living room with dimensions.

Project: Convert these measurements into a 1/4″ scale drawing.

Project: Create a floor plan from your drawing to scale using the answers we have provided for you in the questionnaire.

Worksheet Figure 6–C in Appendix A presents a suggested solution for this project.

Living Room/Family Room/Great Room/Questionnaire
Worksheet 6

Items

1. Which room are we working on?

 A ✔ Living room
 B ____ Family room
 C ____ Great room
 D ____ Den
 E ____ Study
 F ____ Library

2. Do you want to use this room for TV-HiFi-VCR? ✔ Yes ____ No

 Home entertainment? ✔ Yes ____ No

 If so, do you want an entertainment center? ✔ Yes ____ No

3. Do you want to provide for a bar in this room? ✔ Yes ____ No

4. Do you want the bar to be a ____ Wet ✔ Standing ____ Sitdown

5. Do you want to provide an area for books? ✔ Yes ____ No

6. Do you need a sleeper sofa in this room? ____ Yes ✔ No

7. Is a recliner important in your room? ____ Yes ✔ No

8. Do you play cards or games? If so, do you want a card table in this room? ✔ Yes ____ No

9. Do you need a desk? ____ Yes ✔ No

10. Should seating accommodate 6–8 people? ____ Yes ____ No

 8–10 people? ✔ Yes ____ No

 10–12 people? ____ Yes ____ No

11. Do you have any built-ins existing in your room? ____ Yes ✔ No

12. Do you want to provide for display? ✔ Yes ____ No

13. Do you want a fireplace?

 new ____ Yes ✔ No

 existing ____ Yes ✔ No

 existing modified ____ Yes ✔ No

14. The floor plan should include: two 34″ × 72″ sofas, one 30″ end table, one 24″φ end table, a 34″ card table, four side chairs for the card table, triangle-shaped coffee table, swivel chair, and built-ins.

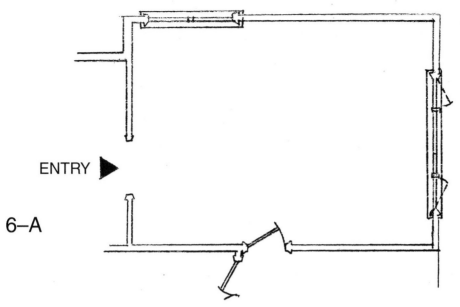

ENTRY ▶

6–A

PLAN OF A PROPOSED LIVING ROOM

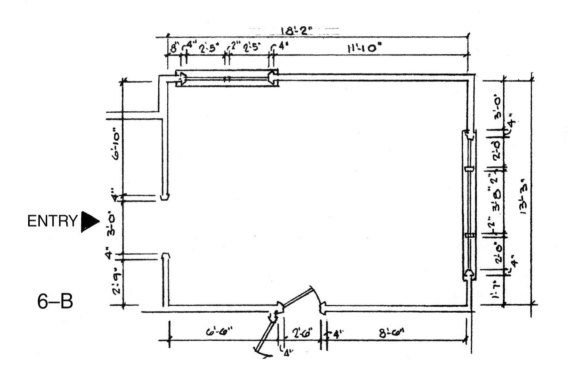

ENTRY ▶

6–B

PLAN INDICATING DIMENSIONS
TO PRODUCE $\frac{1}{4}$" = 1'-0" DRAWING

Worksheets 6–A and 6–B Living Room—Worksheet Illustration

Worksheet 7—Living Room/Dining Room/Kitchen Combination

The following worksheet includes:

Worksheet 7 An answered questionnaire with specific items to be included in the floor plan.

Worksheet 7–A The existing **shape** of the living room/dining room/kitchen combination.

Worksheet 7–B The existing shape of the living room/dining room/kitchen combination with dimensions.

Project: Convert these measurements into a 1/4″ scale drawing.

Project: Create a floor plan from your drawing to scale using the answers we have provided for you in the questionnaire.

Worksheet Figure 7–C in Appendix A offers a possible solution for this project.

Living Room/Dining Room/Great Room/ Kitchen Combination Questionnaire

Worksheet 7

Items

1. Which room are we working on?

 A ____ Living room
 B ✔ Family room
 C ____ Great room
 D ____ Den
 E ____ Study
 F ____ Library
 G ✔ Dining room

2. Do you want to use this room for TV-HiFi-VCR? ✔ Yes ____ No

 Home entertainment? ____ Yes ____ No

 If so, do you want an entertainment center? ____ Yes ____ No

3. Do you want to provide for a bar in this room? ✔ Yes ____ No

4. Do you want the bar to be a ____ Wet ✔ Standing ____ Sitdown

5. Do you want to provide an area for books? ____ Yes ✔ No

6. Do you need a sleeper sofa in this room? ____ Yes ✔ No

7. Is a recliner important in your room? ____ Yes ✔ No

8. Do you play cards or games? If so, do you want a card table in this room? ✔ Yes ____ No

9. Do you need a desk? ✔ Yes ____ No

10. Should seating accommodate 6–8 people? ____ Yes ____ No

 8–10 people? ✔ Yes ____ No

 10–12 people? ____ Yes ____ No

 12–20 people? ____ Yes ____ No

11. Do you have any built-ins existing in your room?

 (Bar) ✔ Yes ____ No

12. Do you want to provide for display? ____ Yes ✔ No

13. Do you want a fireplace?

 new ____ Yes ____ No

 existing ✔ Yes ____ No

 existing modified ____ Yes ____ No

14. The floor plan should include: four stools, host and hostess chair, $30'' \times 54''$ coffee table, $36'' \times 60''$ love seat, $36'' \times 90''$ sofa, $32''$ end table, $42'' \times 108''$ dining table, eight side chairs, $18'' \times 60''$ buffet, $34''$ card table, four side chairs for card table, $24'' \times 44''$ bar, $20'' \times 46''$ desk and desk chair, $15'' \times 48''$ sofa, and back table.

ENTRY

7–A

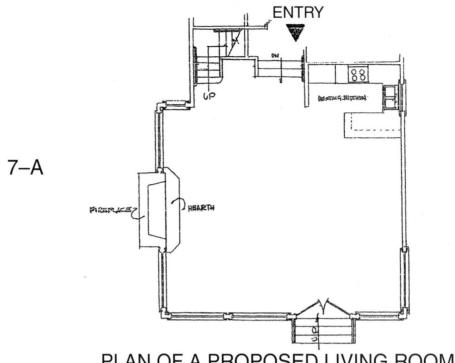

PLAN OF A PROPOSED LIVING ROOM
NOT TO SCALE

ENTRY

7–B

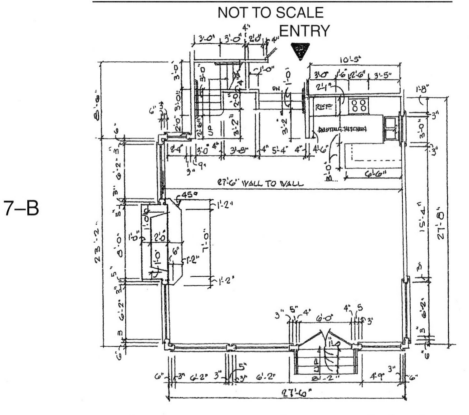

PLAN INDICATING DIMENSIONS
TO PRODUCE $\frac{1}{4}$" = 1'-0" DRAWING

NOT TO SCALE

Worksheets 7–A and 7–B Living Room/Dining Room/Kitchen Combination—
Worksheet Illustration

Suggested Layout Answer 1-C for Worksheets 1-A and 1-B

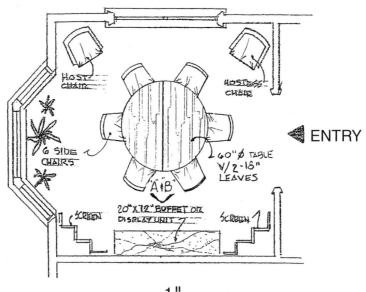

HOST CHAIR

HOSTESS CHAIR

◄ ENTRY

6 SIDE CHAIRS

60"⌀ TABLE W/ 2-18" LEAVES

A&B

SCREEN

20"X72" BUFFET OR DISPLAY UNIT

SCREEN

PLAN $\frac{1}{4}$" = 1'-0"

SUGGESTED LAYOUT

MIRROR OR PAINTING

SERVING CTR

ELEVATION A

$\frac{1}{4}$" = 1'-0"

ELEVATION B

$\frac{1}{4}$" = 1'-0"

Worksheet 1–C Dinning Room

SUGGESTED LAYOUT ANSWER 2-C FOR WORKSHEETS 2-A AND 2-B

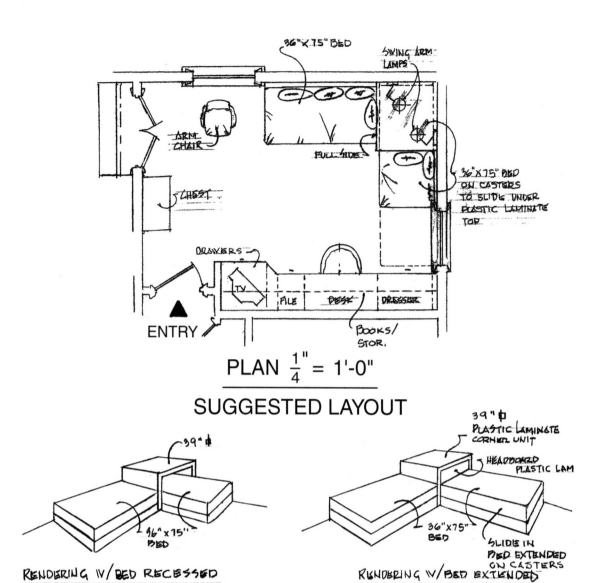

36"X 75" BED

SWING ARM LAMPS

36"X75" BED ON CASTERS TO SLIDE UNDER PLASTIC LAMINATE TOP

FULL SIDE

ARM CHAIR

CHEST

DRAWERS

TV

FILE DESK DRESSER

BOOKS/ STOR.

ENTRY

PLAN $\frac{1}{4}" = 1'\text{-}0"$

SUGGESTED LAYOUT

39" ⌀

36"X 75" BED

RENDERING W/ BED RECESSED
N T S

39" ⌀
PLASTIC LAMINATE CORNER UNIT

HEADBOARD PLASTIC LAM

36"X75" BED

SLIDE IN BED EXTENDED ON CASTERS

RENDERING W/ BED EXTENDED
N T S

Worksheet 2–C Children's Room

SUGGESTED LAYOUT ANSWER 3-C FOR WORKSHEETS 3-A AND 3-B

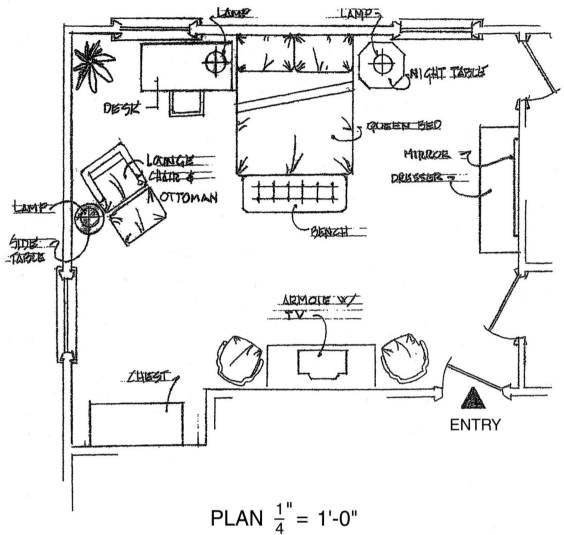

LAMP LAMP

NIGHT TABLE

DESK

QUEEN BED

MIRROR

DRESSER

LOUNGE
CHAIR &
OTTOMAN

LAMP

SIDE
TABLE

BENCH

ARMOIRE W/
TV

CHEST

ENTRY

PLAN $\frac{1"}{4}$ = 1'-0"

SUGGESTED LAYOUT

Worksheet 3–C Master Bedroom

SUGGESTED LAYOUT ANSWER 4-C FOR WORKSHEETS 4-A AND 4-B

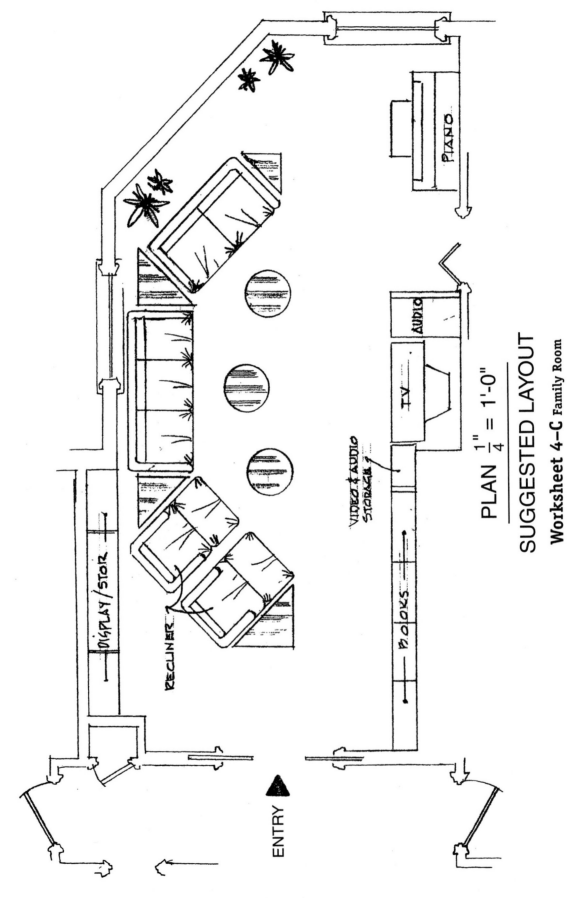

PLAN $\frac{1}{4}" = 1'\text{-}0"$

SUGGESTED LAYOUT

Worksheet 4–C Family Room

SUGGESTED LAYOUT
ANSWER 5-C
FOR WORKSHEETS
5-A AND 5-B

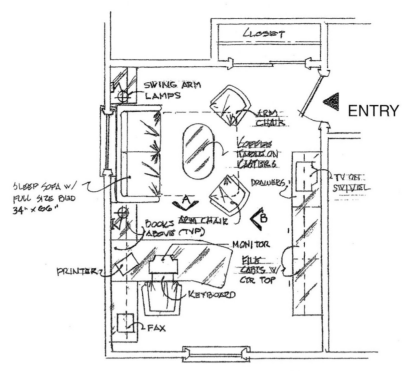

CLOSET

SWING ARM
LAMPS

ARM
CHAIR

ENTRY

COFFEE
TABLE ON
CASTERS

DRAWERS

TV ON
SWIVEL

SLEEP SOFA w/
FULL SIZE BED
34" x 66"

BOOKS
ABOVE (TYP)

ARM CHAIR

A

B

MONITOR

PRINTER

FILE
CABTS w/
CTR TOP

KEYBOARD

FAX

SUGGESTED LAYOUT $\frac{1}{4}" = 1'\text{-}0"$

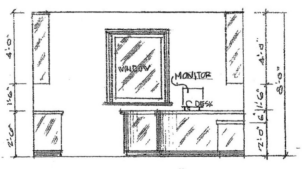

4'-0"

WINDOW

MONITOR

1'-6"

8'-0"

4'-0"

C DESK

2'-0"

6'-6"

2'-0"

ELEVATION A $\frac{1}{4}" = 1'\text{-}0"$

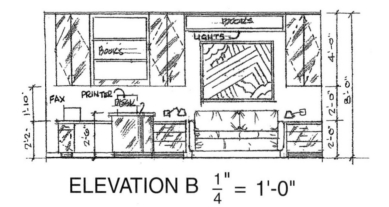

BOOKS

LIGHTS

BOOKS

4'-0"

FAX

PRINTER

2'-2"

1'-10"

2'-0"

8'-0"

2'-0"

2'-0"

2'-0"

ELEVATION B $\frac{1}{4}" = 1'\text{-}0"$

Worksheet 5–C Home Offfice

SUGGESTED LAYOUT
ANSWER 6–C
FOR WORKSHEETS
6–A AND 6–B

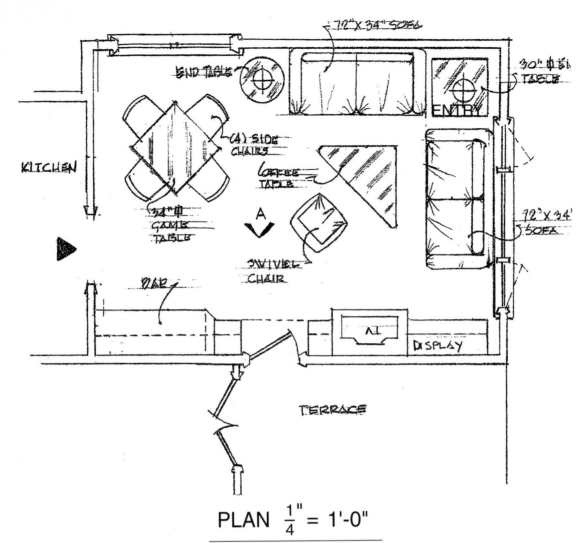

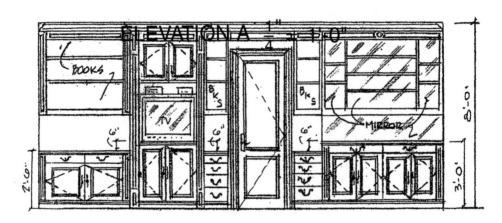

PLAN $\frac{1}{4}" = 1'-0"$

SUGGESTED LAYOUT

ELEVATION A

$\frac{1}{4}" = 1'-0"$

Worksheet 6–C Living Room

SUGGESTED LAYOUT ANSWER 7–C FOR WORKSHEETS 7–A AND 7–B

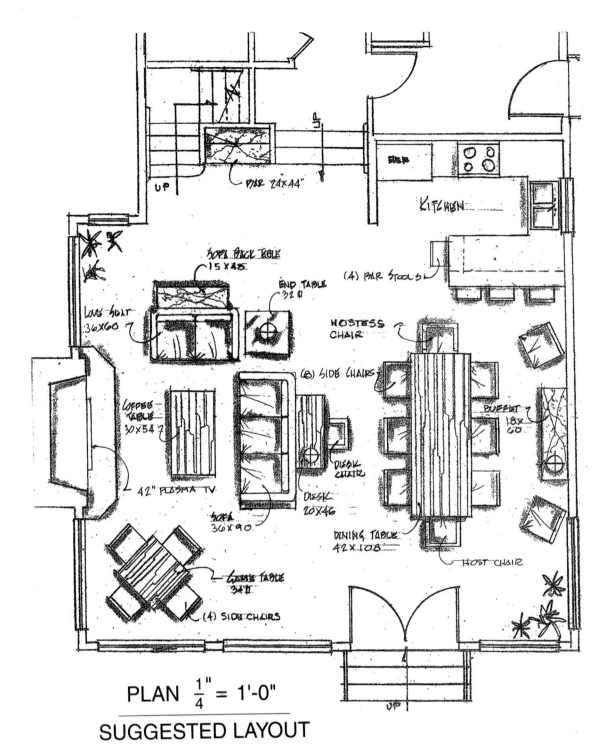

UP

BAR 24X44"

KITCHEN

SOFA BACK TABLE 15 X 48

(4) BAR STOOLS

END TABLE 32 ⌀

HOSTESS CHAIR

LOVE SEAT 36X60

(8) SIDE CHAIRS

COFFEE TABLE 30X54

BUFFET 18X 60

42" PLASMA TV

DESK CHAIR

DESK 20X46

SOFA 36X90

DINING TABLE 42X108

GAME TABLE 34 ⌀

HOST CHAIR

(4) SIDE CHAIRS

UP

PLAN $\frac{1}{4}" = 1'-0"$

SUGGESTED LAYOUT

Worksheet 7–C Family Room/Dining Room/Kitchen Combination